Your Loving Friend, Stanley

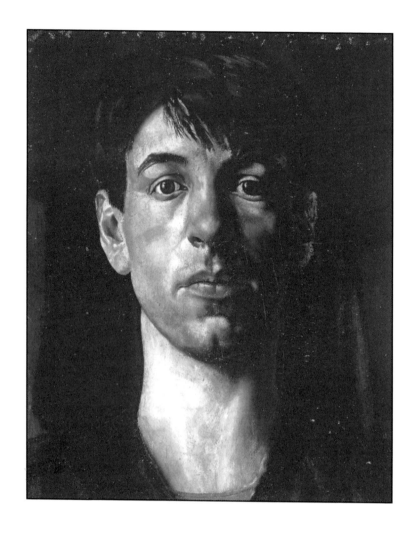

Stanley Spencer: *Self-Portrait*, 1914.
Image © Tate, London 2011
© The Estate of Stanley Spencer 2011

Your Loving Friend, Stanley

The Great War correspondence
between
Stanley Spencer and Desmond Chute

Letters transcribed by
WALTER SHEWRING

Edited and with essays by
PAUL GOUGH

Sansom &
Company

Published with the Stanley Spencer Gallery, Cookham

First published in 2011 by Sansom & Co Ltd.,
81g Pembroke Road, Bristol BS8 3EA

info@sansomandcompany.co.uk
www.sansomandcompany.co.uk

ISBN 978-1-906593-76-6

British Library Cataloguing-in-Publication Data
A catalogue record for this book is available from the British Library

Design and typesetting by Stephen Morris www.stephen-morris.co.uk
Printed by HSW Print, Tonypandy, Rhondda

Contents

Acknowledgements

As ever, I am grateful for the critical dialogue with a growing band of scholars who are developing fresh insights into the extraordinary personality that was Stanley Spencer, amongst them fellow writers Andrew Daniels, Jeremy Harvey, Carolyn Leder and Patrick Wright; custodians and curators Ann Danks, Amanda Findlay, and Chrissy Rosenthal.

I would like to thank Chairman Stuart Conlin and the Trustees of the Stanley Spencer Memorial Trust for their support in making this remarkable correspondence available to a wider audience, and to the Management Committee of the Stanley Spencer Gallery in Cookham for extending a welcome to me on many occasions, not least their invitations to give lectures in the chapel, which is a very special privilege. Grateful acknowledgment is made to those who gave permission to quote material in copyright.

To my publisher John Sansom and editor, Clara Sansom I owe another debt of thanks for helping realize this book, which benefited from the contribution of Dr Alice Barnaby who helped transcribe the letters and offered timely editorial advice. As ever I thank my family for their support and engagement with this project, and I dedicate the book to Isobel, my youngest daughter, in the hope that she realises her ambition one day to become an historian.

Paul Gough, June 2011

Stanley Spencer before the war

STANLEY SPENCER WAS TWENTY-THREE YEARS OLD AT THE OUTBREAK
of war. One of the golden generation that had graduated from the
Slade School of Art in London, the boyish-looking painter would
become famous (and occasionally infamous) for two things in his
intense and at times complicated life: the celebration and immortal-
isation of his home village of Cookham, his 'heaven on earth' as he
lovingly called it, and the fusion in his paintings of sex and religion,
love and dirt, the menial and the miraculous.

Spencer's visionary imagination was realised through many
hundreds of paintings, drawings and thousands of letters. They
reveal a complex understanding of his world and an unrivalled
ability to transform ordinary events into intense images of joyous
delight. Through his detailed narrative paintings Spencer recreated
Cookham – a sleepy village tucked into the Thames some twenty-
five miles to the west of London – into a visionary paradise where
everything was imbued with the utmost importance, whether it be
a chance conversation overheard in the grocer's shop or the idea that
Christ might actually have carried His cross through its streets.
Cookham became a whole world in miniature where, in his ripe
imagination, he and his family and neighbours daily rubbed shoul-
ders with Old Testament figures; and where it seemed entirely
proper that the Resurrection could take place in its churchyard.

It took an extraordinary individual to create such visions and
there was little about Stanley Spencer that was ordinary. Born in
1891 into a large family, he was a slightly built, dark-haired, often
unkempt child, an unstoppable talker, and a voracious reader. His
childhood was saturated with music: each night when he and his
younger brother Gilbert were put to bed, they could hear from
below, the strains of chamber music 'such as they would never
forget', played by members of his extraordinarily talented family.

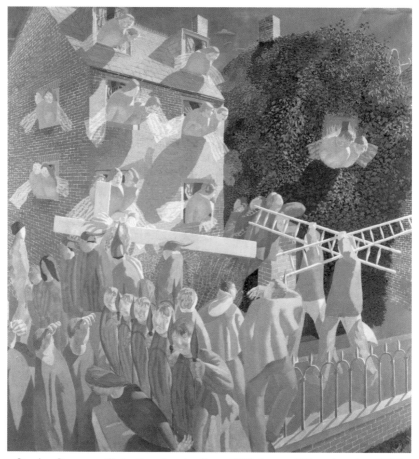

Stanley Spencer: *Christ Carrying the Cross*, 1920. Image © Tate, London 2011

On one memorable occasion, Spencer's revered elder brother Will, a child prodigy on the keyboard, played Bach's *St Anne's Prelude* on the church organ. When asked what it sounded like, Spencer answered in rhapsodic delight: 'Like angels shrieking with joy'.[1]

However, the young Stanley chose an artistic future, not a musical one. In May 1908, son and father, the redoubtable 'Par' Spencer, attended an interview for a place at the Slade School of Art at University College, London. Stanley had been so nervous about the admissions process that 'Par' had to complete the application form, even forging his son's signature. Despite failing the general

knowledge paper, Stanley was offered a place on the strength of his drawing. Having previously ventured no further on his own than the town of Maidenhead, he had to be accompanied to the Slade by his father until he gained sufficient confidence in travelling alone. He was particularly anxious about having to cross the Euston Road on his own.

Once inside the drawing studios of the Slade he earned the nickname 'Cookham' for his incessant high-pitched chatter about his home village and his gauche unworldliness. His younger brother, Gilbert, described his unprepossessing appearance as a student as 'boyish, being little more than five feet tall, wearing Norfolk jacket, Eton collar, jersey, breeches and long stockings. His youthful image was emphasised by his tousled black hair, fresh, rosy complexion and general untidiness.'[2] Spencer thrived under the direction of the staff at the Slade, spurred on by the competition from an extraordinary cohort of fellow students, amongst them Richard Nevinson, Mark Gertler, Dora Carrington, Isaac Rosenberg, David Bomberg, Paul Nash, and Edward Wadsworth – artists who would play a major part in the story of British painting over the next few decades. He gained a reputation as a draughtsman of extraordinary dexterity, capable of evolving complex narratives that were exactly attuned to the Biblical and mythical subjects set by the formidable masters. Henry Tonks, the most eminent of his tutors, later described Spencer as 'having the most original mind of anyone we have had at the Slade and he combines it with great powers of draughtsmanship'.[3] Spencer won many of the School's important drawing and composition prizes and left the School in 1912 in 'a blaze of glory',[4] returning to Cookham, his 'heaven on earth', and to the domestic throng of 'Fernlea' where he would set up his easel anywhere space could be found, 'mostly on the corner table in the dining-room.' His work had already aroused critical interest. It was being shown in the better galleries and had started to find ready buyers and a network of admirers and supporters. He was one of a handful of young British painters whose work was selected by Roger Fry to hang alongside Gauguin, Van Gogh, and other continental painters in the seminal second Post-Impressionist show that so divided the London art world in 1912.

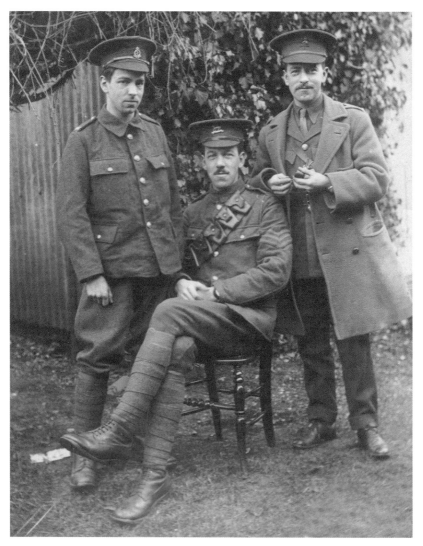

Three of the Spencer brothers on leave in Cookham.
From left to right: Private Stanley Spencer, Sergeant Percy Spencer,
Lieutenant Sydney Spencer

Despite his self-imposed semi-isolation in rural Berkshire, Spencer maintained regular contact with a tight network of London-based friends and patrons who recognised his innate genius. One such mentor was the painter Henry Lamb who bought his work and introduced him to a coterie of artists, art lovers and their circles of patrons and buyers. Eight years older than Spencer, Lamb played a crucial (if at times, almost invisible) role in Spencer's development during the coming decade, assuming the role of worldly patron to Spencer's 'provincial innocent', the sun to Spencer's planet.[5] At first both basked in the relationship, although over time Lamb developed an ambivalent view of the younger man's complex personality, ever admiring the painter but at times wary of his peppery side, irritated on occasion by his obsessive pre-occupations with his own domestic and personal problems. Like so many of the older men that Spencer befriended during the course of his adulthood, Lamb was a remarkably tolerant and enabling patron, readily offering money, accommodation and professional support that was not always appreciated, even acknowledged, by Spencer. Despite his idiosyncratic charm, Spencer's company was often exhausting, his literal nature and endless self-referential chatter (to say nothing of his 'unblinking candour'[6]) made him a wearying – although always engaging, if sometimes prickly – companion, and Lamb twice failed to finish a portrait of the younger artist largely on account of Spencer's inability to sit still for long enough and to stop talking.

Outbreak of war

Within a month of the outbreak of war in August 1914 Stanley and his brother, Gilbert, had joined the Maidenhead Branch of the Civic Guard, where they practised rushing about the local park with wooden rifles. Given Spencer's stature, weekly drill made an interesting spectacle. 'I am 5ft 1 inch,' he wrote, 'the man next to me last night was 6ft!'[7] Spencer's martial zeal was not to be realised. Both brothers were persuaded by their mother to seek enlistment for Home Hospital Service in the Royal Army Medical Corps (RAMC) as she insisted that neither of them would have the stomach for fighting. Being both energetic and patriotic, the brothers were not

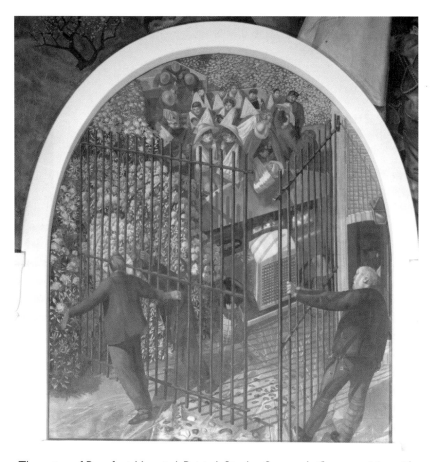

The gates of Beaufort Hospital, Bristol: Stanley Spencer's *Convoy arriving with the wounded*. Sandham Memorial Chapel, Hampshire (National Trust)
Photograph ©NTPL ©The Estate of Stanley Spencer 2011.

much taken by this option. Within weeks, there came ominous news:

> ... Gil went to a hospital at Bristol: an awful place and awful hospital; I may go there. ... Wherever I go it is bound to be vile, but I am prepared for anything. I expect my duties will be cleaning out lavatories & taking the 'Pan' around the ward. It seems such rotten luck that Gil and I had to do this instead of being 'tommies'...[8]

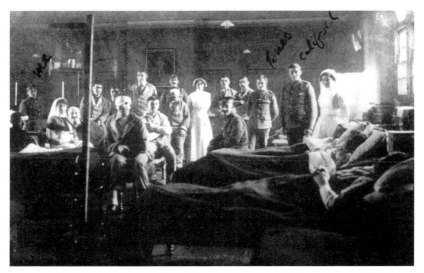

On the ward at Beaufort. Spencer is on the left, marked 'me'

Spencer was soon called up for home service too and he was horrified to find that he also had to go to Bristol, to the former lunatic asylum on the outskirts of the city that had been turned over for military use. Despite being forewarned by Gilbert, nothing prepared him for its coarse and unwelcoming appearance, and years later he still recalled his terrifying arrival at 'the Beaufort':

> The gate was as high & massive as the gate of hell. It was a vile cast iron structure. Its keeper, though unlike that lean son of a hag who kept the gate of hell being tall & thick, was nevertheless associated with that auspicious gentleman being the man who had charge of all the 'deaders' & did all the cutting up in all the post mortem operations. I could imagine him cutting my head off as easily as I imagined him cutting off chunks of beef.[9]

Apart from 45 patients retained to work the farm, the service departments and the kitchen garden, its patients had been evacuated to rural asylums in the south-west, some as far afield as Cornwall and Dorset. At War Office expense, three industrious months were spent converting the asylum to take up to one and a half thousand wounded soldiers. Day rooms and night wards were converted into

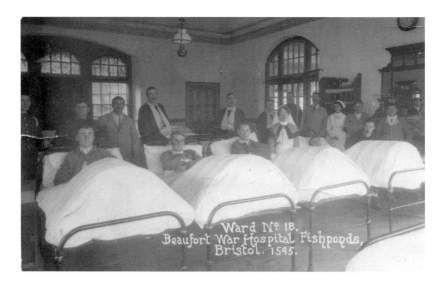

Ward No. 18.
Beaufort War Hospital Fishponds,
Bristol. 1545.

twenty-four medical and surgical wards, corridors were refurbished to cope with emergency admissions. Even the maximum restraint cells were requisitioned. Throughout the asylum, rooms were adapted to become operating theatres, radiography departments and pharmacy stations. Contemporary photographs show that the hospital retained some of its pre-war character, and the wards are strewn with large potted plants and ornate furnishings, though little could disguise the hard deal tables, the flagstone floors and the high windows with their cast-iron glazing bars.[10] Stanley Spencer can be clearly seen in one of these photographs – a diminutive figure in an ill-fitting tunic surrounded by long avenues of beds, each separated by a large, ungainly wooden locker – marked up in ink with the word 'me' hovering over his head.

Just as the building was modified for military use, so its personnel were given new roles. Most of the permanent staff found themselves now working for the military. The Asylum Superintendent became a Lieutenant Colonel in the medical corps, his horse-drawn cab was replaced overnight with a motor car and he moved into an official apartment in the administrative block. Other medical personnel were appointed. Twenty-five physicians and surgeons arrived and a registrar was appointed as deputy to the colonel. There survives one photograph taken on the steps of the ivy-clad

Beaufort War Hospital, Fishponds, Bristol. 1478.

central block in 1915, which shows a group of nineteen officers, with the ranks of major and captain, and all but one – Jarvis – sporting rather fierce moustaches.

Spencer, a lowly orderly, was rightly respectful of the officers, but he was very wary of the female staff. As had been the case with their male counterparts, the asylum wardresses were converted overnight into nursing assistants, but few were promoted, instead they were supervised by fresh intakes of trained nurses drawn from the Red Cross, who in turn were managed by experienced ward sisters drawn from the Queen Alexandra's Imperial Military Nursing Service Reserve. In charge of this contingent of some fifty staff was the newly appointed hospital matron, Miss Gibson, who supplanted the former asylum matron. Orderlies, two to each ward, were at the bottom of the hierarchy, and they worked under the autocratic command of the Ward Sister.[11]

Veterans of the Great War had little affection for the military hospitals; many complained of an inhumanity that seemed to increase with distance from the battlefield. At the front, wounded soldiers were treated by fellow-combatants and by familiar regimental doctors. 'The wounded man,' recalled one soldier, 'is in a moment a little baby and all the rest become the tenderest of mothers. One holds his hand; another lights his cigarette. Before this, it is given to

few to know the love of those who go together through the long valley of the shadow of death.'[12] All this changed in the rear of the battle zone and in the general hospitals back in 'Blighty'. Indeed, their journey from the front might be surprisingly quick. Gilbert recalled his first terrifying moments at Beaufort when he was surrounded by a 'ward full of wounded Gallipoli soldiers, their skins sunburnt and their clothes bleached and the soil of Suvla Bay still on their Boots.'[13] Henry Williamson in his novel *The Patriot's Progress* left a more sympathetic account of his time in military hospital:

> Months and months of pain and contentment: regular grub and fags, military band outside once a week, and sometimes a theatre, riding in a toff's car, though his character also remembers 'the terrible silence of the white wards, the swish of felt slippers, the terrible white walls and crying, the strange white sheets and beds in a row.'[14]

Most veterans, however, remembered the casual brutishness of convalescence and the uneasy tension between the wounded and their non-fighting guardians, with their cushy jobs and protected status. After all, the main function of the military hospital was to patch up the fighting man and to return him to fighting fitness as soon as possible. To many soldiers, duty back in the front line became something of a release from the petty regime, the harsh treatment and studied indifference of the British military hospital.

Through the 'Gates of Hell'

Passing through the 'Gates of Hell' signalled a change in Stanley Spencer. He felt trapped in a place for which he was utterly ill-prepared. In a short space of time, Beaufort shattered the stillness and unity of his enclosed world, but in so doing stimulated the enquiring and curious side of his creative mind that had remained dormant until then. However, he was not to understand this for some time. At first the asylum-cum-hospital brought on a massive crisis in the young painter. It was a place that brought 'innumerable unanalysable mental shocks that continually beset me'. However,

being naturally energetic and robust, Spencer soon found his feet. Drawing on his natural ebullience and his incorrigible interest in everything around him, his second day found him in better spirits:

> I had to scrub out the Asylum Church. It was a splendid test of my feelings about this war. But I still feel the necessity of this war, & I have seen some sights, but not what one might expect. The lunatics are good workers & one persists in saluting us & always with the wrong hand. Another one thinks he is an electric battery...[15]

While the Beaufort may have tested Spencer's mental and spiritual capacities, he proved more than able to meet its vigorous physical demands. In fact his work was little more than hard labour in a uniform. Following an early morning parade or physical training he would be tasked, with at least two other orderlies, to work in a ward, usually Number Four. There he would spend a long day – usually ten, sometimes as long as fifteen hours – at the beck and call of the nursing sister.

Like so many rankers, Spencer was largely unaware of what was happening around him or what next to expect. These changes of pace left him vulnerable, often unable to cope, and seized by a profound sense of loss. He wrote home to say that he was 'horribly fed up' – 'I get no exercise, drill and that is what I thirst for. I know what drilling is … Ever since I have been here, I have done nothing but scrub floors.'[16] By December 1915 he was at his lowest ebb.

Notes

1 Elizabeth Rothenstein, *Stanley Spencer* (Oxford and London, Phaidon Press, 1945) p.7

2 Richard Carline, 'Stanley Spencer: his personality and mode of life', in *Stanley Spencer R.A.*, catalogue of the Royal Academy exhibition, 1980, p.11. This story is also told in Spencer, Gilbert, *Stanley Spencer* (London: Gollancz, 1961) p.107, reprinted Redcliffe Press, 1991; and cited in Collis, Maurice, *Stanley Spencer* (London: Harvill Press, 1962) pp.37-38

3 Andrew Causey, 'Stanley Spencer and the art of his time', in *Stanley Spencer R.A.*, catalogue of the Royal Academy exhibition, 1980, p.23

4 Maurice Collis, *Stanley Spencer* (London: Harvill Press, 1962) p.39

5 Stanley Spencer to Henry Lamb in 1919, quoted in Clements, Keith, *Henry Lamb: the Artist and his Friends* (Bristol: Redcliffe Press, 1985) p.214. After his first visit to meet Henry Lamb, Stanley wrote to the Raverats, 'I like him & do not feel him to be a low worm. I do not think his work is interesting except sometimes.' (15 December 1913, Tate Gallery Archive (TGA) 8116.32) It is important to note that extracts and references to Spencer's letters in the Tate Gallery are reproduced in full, with contextual material and contemporary photographs, in Adrian Glew's excellent compilation of the Spencer writings. See bibliography

6 This phrase is Kenneth Pople's, who has a fine and sympathetic reading of Stanley's complex character. From the author's conversations with Pople, 2004-05. See Kenneth Pople, *Stanley Spencer: a biography* (London: Collins, 1991)

7 Stanley Spencer to Gwen Raverat September 1914, TGA 8116.41

8 Stanley Spencer to Henry Lamb, 19 July 1915, TGA 945.27

9 Stanley Spencer, *Account*, 1918, TGA 733.3.83

10 For a full account of the conversion of the hospital see Paul Gough, *Stanley Spencer: Journey to Burghclere* (Bristol: Sansom and Company, 2006)

11 See Donal Early, *'The Lunatic Pauper Palace': Glenside Hospital Bristol, 1861-1994: its birth, development and demise* (Bristol: Friends of Glenside Hospital Museum, 2003) p.35.

12 J. Wedgwood, *Essays and Adventures of an MP* (London: Allen and Unwin, 1924).

13 Gilbert Spencer, *Stanley Spencer by his brother Gilbert* (London: Gollancz, 1961; reprinted, Redcliffe Press, 1991) p.137

14 Henry Williamson, *The Patriot's Progress*, pp.189-191

15 Stanley Spencer to Gwen Raverat, July/August 1915, TGA 8116.54

16 Cited by Richard Carline, *Stanley Spencer at War* (London: Faber, 1978) p.53

Meeting Desmond

SPENCER FELT TRAPPED IN BRISTOL. HIS TEN MONTHS IN THE MILITARY hospital felt like a prison sentence. In his eighty-eight notebooks, his thirteen diaries and nearly one thousand extended pieces of reflective prose, he often ruminated about the impact of the 'Beaufort' on his subsequent career as an artist. Sometimes he remembered the hospital fondly, especially after dark 'with the feeling of night, slippers, go quietly, terrible operations, uncanny supernatural atmosphere ...' At other times he remembered the hospital as a vile, degrading place where the 'utterly selfish spirit' of his fellow-orderlies made him 'wild'.[1] It was some small comfort that his brother served as an orderly in the same institution, even though Gilbert had once described the asylum as a place where 'anything less likely to provoke creative art would be impossible to imagine.'[2]

However, despite his obscurity in the teeming metropolis of the Beaufort, Stanley's status as an artist became common knowledge in late 1915 when his name appeared in an exhibition review in the national press. Scrubbing the floor of the hospital dispensary one morning he was cornered by the imposing figure of a one-legged Gallipoli veteran looming over him and demanding to know if this same slight, scrubbing figure were the same 'Stanley Spencer' so lavishly praised in the newspaper – *The Times* – that he was dangling in front of his nose. Spencer remembered the soldier bellowing, 'Is that you, you little devil?'[3]

Spencer was right to be astonished: he had no idea that his paintings, amongst them *The Centurion's Servant*, which had been selected by Henry Tonks for the New English Art Club autumn show in London, would be so well received. As he later wrote, 'I had almost forgotten my fading past. It made a strange impression on me.'[4] The remarkable news spread the length of the hospital with fascinating results:

The matron, a tall gaunt creature before whom Queen Mary looked quite a crumpled thing, came down the ward with a veritable sheaf of dailies under her arm determined to track down this great unknown. Even she looked a little less grim and gaunt. These notices were very welcome to me. I had been terribly crushed. They gave rise to such teasing remarks from the Sisters as, 'When are you going to get that commission, orderly?' having scented I was a bit different, or thought I was.[5]

As his reputation spread around the Beaufort, Spencer was asked to draw his fellow orderlies and patients. He felt rather rusty at first and gave most of his work away, although the pieces that survive exhibit his habitual high standard of draughtsmanship and sensitivity to the sitter. Even on overseas and active service he would be pestered for drawings. He was glad to oblige:

I do anything for these men. I do not know why but I cannot refuse them anything & they love me to make drawings of photos of their wives & children or a brother who has been killed. A diary of a man who was killed chronicled the weather day after day & as you read these monosyllables it gives you an intensely dramatic feeling.[6]

However, there was little relief from the grinding routine of the hospital and Spencer applied for overseas service in late autumn 1915. While he waited he was faced with the relentless tedium of fetching, carrying, washing and scrubbing. However it was during that much-loathed act of scrubbing floors that Spencer met a key figure in his time at Bristol: a young man by the name of Desmond Macready Chute. He knew Spencer's art and could barely believe he was working in Bristol: he too had seen the piece in *The Times* and made his way into the workings of the former lunatic asylum to track down this well-known painter. This meeting and their subsequent friendship would exert a powerful influence on Spencer's thinking about art, religion and the imagination, and have a profound impact on his development as a painter.

Who was Desmond Macready Chute? He was born in Bristol on 11 September 1895 (making him four years younger than Stanley

Spencer) into a family steeped in the theatre. Indeed, the *Bristol Evening News* had heralded his birth as an event of 'dynastic proportions' raising great expectations for his future contribution to the life of theatre in the city. He was a collateral descendent of William Charles Macready, the eminent Shakespearian actor. His grandfather, John Henry Chute, had created a new theatre in Park Row Bristol, converting it, at lavish cost, from an old mansion known as Engineer's House into the Theatre Royal which opened wide its doors in October 1867 with a production of *The Tempest*.[7] The Chutes were nearly bankrupted by the conversion costs and, in 1869, John Henry was further devastated by a catastrophic accident when over a dozen theatregoers were crushed to death in the constricted space of the pit and gallery. John Chute's sons, James and George, restructured the seating, installed plush refreshment rooms and, in 1884, renamed it the Prince's Theatre, where it played host to nationally renowned touring companies, such as the D'Oyly Carte, and major figures such as Henry Irving. But it was the perseverance of James – 'Jimmy' as he was known – and his young wife, Abigail, that saw the 'Prince's' become renowned as one of the grandest and most comfortable of all provincial theatre venues, famous far and wide for its extravagant and lively pantomimes. Jimmy not only owned the Prince's Theatre in Bristol, he was also director of the Prince of Wales Theatre in Birmingham and the Gaiety Theatre in Dublin.

Abigail became one of the city's best known characters and a prominent hostess in fashionable and artistic circles. Second daughter of Joseph Hennessy, a prominent Bristol Liberal and successful businessman in the cattle trade, she was renowned for her charismatic and energetic manner, particularly adept at fostering good relationships with leading actors of the day. Indeed, her friendship with Ellen Terry, Mrs Patrick Campbell and Sarah Bernhardt ensured that the country's most eminent thespians trod the boards on Park Row and many of the profession's better designers were lured to create costume and sets for the company. The well-known designer Charles Wilhelm, for example, created the costumes for all the pantomimes between 1882 and 1886, bringing a sumptuous extravagance to such standard productions as *Dick Whittington*, *Forty Thieves*, and *Red Riding Hood*. In the years

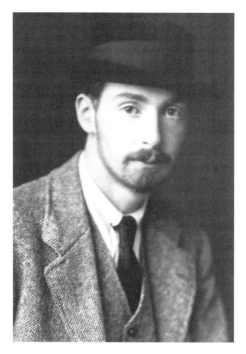

Desmond Chute as
a young man

before the Great War, the settings for the pantomimes reached new levels of brilliance. Photographs of the gardens of 'Aladdin's Palace' or the streets of 'Chang-li Hang', for example, show highly wrought architectural back-drops and stage flats, with teeming cascades of painted flowers and vast oriental vistas.[8]

Jimmy and Abigail expected much from their son Desmond when he was born in 1895, and even more so when Jimmy died suddenly in 1912, with Desmond only just seventeen years old. Desmond, however, appears to have had little interest in the theatre. Nothing could be more removed from his love of classical poetry and Baroque music. Perhaps he found the painted artifice of the pantomimes rather vulgar. Even before his father's untimely death, he had set his mind on leaving Bristol, not however for an assured place in the ivory towers of Oxford but for London, leaving the theatre to be run by his mother and her co-director John Hart. By all accounts, Abigail thrived in the role of matriarchal figure. A tall, dignified, even regal Victorian lady in her early sixties, she towered over the theatrical world of Bristol, 'dominating it', some said, 'with great determination'.[9]

In Clifton

Strolling through Clifton, caught in enrapt conversation, Stanley and Desmond must have presented a rather curious pairing. Stanley, just over five feet high, slightly unkempt and boyish in his manner, Desmond 'thin and very tall, a long pale face, with lots of hair and a reddish beard', his outwardly wearied manner masking an intense intelligence. Ezra Pound's daughter recalled, some twenty years later, her lasting impressions of him, a man of 'good mind and a noble spirit handicapped by a languid appearance':

> His health was poor, his eyesight very delicate. But his discipline must have been adamant, for he could not otherwise have been such an accomplished and honest dilettante. He did everything with extreme 'diletto' and care, never pretending to be a great artist. He was extremely reserved...he remained for me somewhat of a mystery man.[10]

A devout Roman Catholic, like his mother Abigail, Desmond was revered by Spencer as being 'brilliantly clever with all that spiritual outlook and vision and mystery looked and longed for'.[11] Chute was indeed brilliant. Head of School at St Gregory's, Downside (the renowned Catholic School in north Somerset) he was an assured classicist, an accomplished pianist and musician, and a gifted painter. Despite the easy lure of Balliol at Oxford or King's College, Cambridge (which would have pleased both his parents), he eschewed an academic destiny to study at the Slade School of Art in London where he enrolled in 1913, not long after Spencer had left. His studies were interrupted by the outbreak of war in August 1914 and he returned to Bristol, blighted by indifferent health which precluded him from military service of any kind. Unfortunately, the family business appeared to hold little interest for the young man. Instead, he spent his time studying, reading, and refining his tastes in classical literature and fine music, but as the 'man of the house' he acted as host to his mother's frequent and lavish soirées which attracted the great, the good and the glamorous to their large villa, Abbeymeade in Elton Road, Tyndall's Park, Clifton. The house is

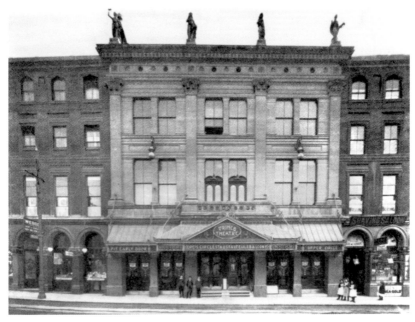

The Chute family's Prince's Theatre on Park Row, Bristol and *below*,

Bristol City Art Gallery as Stanley would have known it, before the
University was built next door
[photographs: courtesy Reece Winstone Archive]

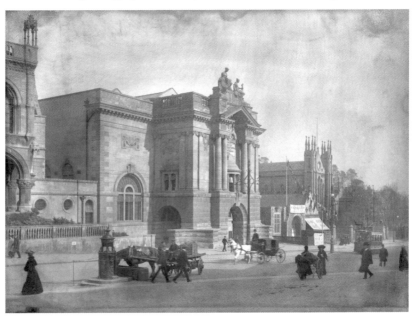

there still, an imposing four-storey town house, close to the City Museum and Art Gallery and within walking distance of the Royal West of England Academy and its School of Practical Art. During one of Abigail's celebrated 'At Home' receptions in 1915 a guest revealed news of an interesting, if slightly novel, visitor to the city. Lieutenant-Colonel Blachford was the commanding officer of the Beaufort Hospital, having been promoted from his civilian role as the Superintendent of the Bristol Asylum (a post he held for two decades between 1904-1922) into the head of the Royal Army Medical Corps contingent that now administered the hospital and cared for its thousands of wounded and convalescent soldiers. He had heard that a young painter was amongst the several hundred medical orderlies then serving in the Beaufort. Naturally he passed the gossip on to the artistic circle that gathered around Abigail in Tyndall's Park. Desmond knew of Spencer both by reputation, which lingered long at the Slade School, but also by his standing as an emerging young artist. He appears to have read the very same review in *The Times* that had alerted the Gallipoli veteran in the Beaufort. Whatever the cause, Chute went to seek out the painter. Spencer recalled (and clearly slightly embellished) the impact of their first, strange meeting:

> It was about this time when I was wondering how to get the mental energy to make the work bearable … that I had a visit from a young intellectual of sixteen [Chute was actually twenty years old] who, like Christ visiting Hell, came one day walking to me along a stone-coloured passage with glass-coloured windows all down one side and a highly patterned tile floor... I had a sack tied round my waist and a bucket of dirty water in my hand. I was amazed to note that this youth in a beautiful civilian suit was walking towards me as if he meant to speak to me; the usual visitors to the hospital passed us orderlies by as they would pass a row of bedpans. The nearer he came, the more deferential his deportment, until at least he stood and asked me with the utmost respect whether I was Stanley Spencer.[12]

Feeling abandoned and isolated from intellectual sustenance, Spencer

The Chute house, Tyndall's Park Abigail Chute

sensed an instant affinity with the younger man. He found him widely
read, deeply thoughtful and intense, sensitive to the point of being
withdrawn and reserved, 'nervous & generally not suited to "Society"
with large round eyes that are very searching, contemplative, severe,
gentle and *charitable*, in the one & only sense of the word'.[13] It was a
perfect match. From then on, during the remainder of his posting to
Bristol Spencer spent every moment of his free time with Chute:

> If I were able to express how much this hospital life and atmosphere
> was cut off and out of the power of any other power than itself, I
> could make it clear what I felt at the moment of meeting. Compared
> with the crushed feeling the place gave me, the army and the war
> took upon themselves something of the freedom that one felt about
> civilian life in peacetime. The appearance of this young man was a
> godsend. He was terribly good and kind to me and appreciated the
> mental suffering I was going through.[14]

Granted 36-hours' leave each month. Spencer spent it entirely in

Chute's company, either wandering the broad leafy streets of Clifton locked in deep conversation, reading poetry and classical literature in Chute's rooms at Tyndall's Park, visiting bookshops[15] or taking part in rounds of visits amongst the musical and artistic cliques of the city. Both men would have been aware of such organisations as the Clifton Arts Club, and Spencer may have known that the young Henri Gaudier had attended drawing classes in the impressive Life Room at the School of Practical Art in Queen's Road. Exuberant in sympathetic company, Spencer thrived in the artistic sets of Clifton and, later on active service overseas, he enquired of Chute: 'Any news of the friends you have introduced me to would delight me. How is Miss Krauss, Miss Pierce, Miss Smith, the Misses Daniell, Mrs D. & Mrs Press?'[16] Chute, like Henry Lamb a year earlier, found in Spencer an ideal pupil, thirsty for literary and musical enrichment. It was a perfect match:

> When I used to visit him [wrote Spencer to his sister, Florence], he used to translate so much [of the Odyssey] and then read it in the original. Mind you, if he was to read about two pages he could go through to order, whether he had the book or not. Sometimes when we have been out for a walk – wonderful walks – I would begin to ask him about some particular novelist and he would go through the whole novel quoting pages and pages, quite unconsciously.[17]

Spencer's memories of Bristol – as distinct from 'The Beaufort' – were rich and warm ever after. He later recalled:

> When I first met Desmond we used to end up by going to a house containing a widowed Scots woman, she did anything for me, & sang anything Desmond and I wanted her to & nothing else …of the Byrd period … & Italian & French things….And then she used to do some Mozart & Gluck (I should like to hear a Gluck opera). Desmond used to play parts of 'Alceste' …& it quickened my appetite for him. When I think of the wonderful quiet evenings I have spent in Chute's bedroom with the sunlight filling the rooms & Desmond surrounded with the wildflowers which he loved. He

loves sorting them out. I used to sit looking out of the wide-open windows & listen to him translating Homer's Odyssey & Iliad…. Our evenings were so satisfying.[18]

Chute's other impact was no less welcome during Spencer's spiritually and materially beleaguered existence in Bristol. Indeed, it probably had longer-lasting importance for his growth as an artist: Chute introduced him to the *Confessions of St Augustine*. Spiritually and emotionally, it was a critical breakthrough for the painter:

> There is a glorifying God, in all His different performances. This struck me very much … Ever busy, yet ever at rest. Gathering yet never needing, bearing, filling, guarding, creating, nourishing, perfecting, seeking though thou hast no lack! And so I thought 'bearing, filling,' coming, going, fetching, carrying, sorting, opening doors, shutting them, carrying tea-urns, scrubbing floors, etc. Yes, he was a friend indeed. I never disliked doing any of these things; … sweeping up had become part of the performance of painting the picture afterwards.[19]

St Augustine's writings about the spiritual value of menial service validated Spencer's role in the hospital; he now recognised the nature of his sacrifice and the reasons for his servitude to the greater cause. His reading of the *Confessions* provided 'the key to the redemption he so desperately sought'.[20] 'Ever busy, yet ever at rest. Gathering yet never needing' offered him the spiritual bridge between the mundane and the miraculous; his menial role could now be seen as a service to God.

Thereafter, hospital work became not a source of grinding irritation, but one of inspiration. Scrubbing floors – his daily chore in the hospital – took on an elevated meaning. Not only was it associated with his first memories of meeting Chute, but it created a spiritual, and aesthetic, experience that Spencer could now savour. Recalling his labours in the bathroom of the medical inspection ward:

> Now and then, I was hired from [Ward] 4A to scrub this stone-

floored bath-room and I used to enjoy it rather. The orderlies might give me a bit of cake … and the sister would condescend a little. I liked the surface of that floor and the colour was very good – some parts faded india-rubber red, and some more ochre and peach-like. The bath-room of [Ward] 4B was quite different. It was more jolly and matter of fact and had a deal-board floor and free and easy entrance and exit. It was the way through to the lavatories, so that there was continual passing through … Yet here in 4B bathroom, the more noise, the more men and general washings and bathings took place, the more a certain atmosphere and special character became enhanced. It was the hospital in its more robust form.[21]

In St Augustine, Spencer uncovered a metaphysical model that made sense of the menial grime of so much of his time in the hospital. He now realised that through volunteering he had sacrificed himself and his art to servitude in the hospital: through his suffering, through carrying this burden, he could now comprehend why he had been sent to the Beaufort. Chute had revealed the nature of his sacrifice: Stanley was released into a state of visionary ecstasy. Furthermore, the *Confessions* gave him a spiritual permission to be inspired:

I think doing dressings, when you are allowed to do the things in peace and quiet, is quite inspiring. The act of 'doing' things to men is wonderful … What a subtle thing is the change from one thing to another, no matter what it is … Now I am sweeping; now I am cleaning dishes; now I am polishing. There is such unity and yet variety in it.[22]

Spencer even likened these feelings of spiritual and aesthetic unity to the Biblical tales carved in bas relief on Giotto's Campanile. He sensed then that there were drawings and paintings that might result from this experience. 'After my days work at Beaufort, I have wanted to draw a picture of everything I have done. But why … I could not say.'[23]

Sadly, there is no record of Chute's observations or thoughts about Spencer's transformation. He could not help but have been impressed

by his friend's fortitude and his unerring ability to find value in such grim labour. He must have recognized, however modestly, the huge part he had played in restoring Spencer's creative confidence.

Towards the end of the war Chute met the artist Eric Gill for the first time. He had learned that Gill was carving the *Stations of the Cross* in Westminster Cathedral in London. Just as he had done a year or so previously in the Beaufort, Chute walked into the cathedral and introduced himself to Gill. The outcome was as significant for Chute as had been his meeting with Spencer, although on this occasion the roles were reversed. 'Henceforth, Eric Gill was master and Desmond was disciple – a master by no means infallible, a disciple by no means uncritical; but master and disciple they were and remained.'[24] Soon after, Chute left Bristol, more or less for good, and joined Gill's community of Catholic artist-craftsmen at Ditchling in Sussex, where he studied carving and became a close and life-long friend of both Gill and a fellow apprentice, artist, writer and convalescing war veteran David Jones.

Back in Bristol, after ten months of grinding menial labour in the Beaufort, Spencer, ever restless and ever curious, volunteered for overseas service and, after a lengthy period of training near Aldershot, was sent to the 'forgotten' front in Salonika to serve in one of the many field ambulance units. During the next thirty months of active service he maintained a correspondence with Chute. These letters offer a fascinating insight into Spencer's travels, his first time overseas, and the trials that beset him. When he finally came to paint his extraordinary vision of life as a medical orderly he looked back on his time at the hospital and wrote lovingly:

My intention was to attempt to express the very happy imaginative feelings [I] had in that hospital revealed through my different performances & leading to a kind of redemption of the atmosphere & feelings that the place & circumstances gave me. ... I had, as I said, a longing to experience all these hospital performances minus the harassing atmosphere I lived in & the pictures were largely an outcome of this wish.[25]

Notes

1 Spencer, TGA 8116.58. Stanley to the Raverats, August (?) 1915, TGA 8116.55. Stanley first made a record of his war experience in 1919 (held in the Tate Gallery Archive as TGA 733.3.28). This draft formed the basis of a notebook written as he developed his ideas for the Oratory at Burghclere (TGA 733.3.84). This notebook was typed up in 1948 (TGA 733.3.85). A section was later added to this typescript (TGA 733.3.128). Collis quotes liberally from these letters, as does Pople, and Glew has assembled an authoritative compilation. See bibliography.

2 Gilbert Spencer, *Stanley Spencer by his brother Gilbert* (London: Gollancz, 1961; reprinted, Bristol: Redcliffe Press, p.136)

3 Spencer, *Reminiscences*, Glasgow 1945-47, TGA 733.3.86. Spencer recorded the episode with the Gallipoli veteran in a letter to Sir William Rothenstein written but never posted in May 1938. 'I had been a Tommy for nearly six months then, so that a reminder of my former life came like an apparition of myself. I have often felt how much that little notice meant to me right through the war.' (cited in Maurice Collis, *Stanley Spencer*, pp.46-47)

4 TGA 733.3.86

5 Spencer, TGA 733.3.85 This is Spencer's only mention of the royal visit of September 1915, a visit that was a highlight for most at the hospital, but only a sideshow for the painter.

6 Letter 19. Although the date appears to read 'Jan.4th 1916' Spencer has corrected the '6' with a '7'. As 1917, it makes sense in the order that they were transcribed by Shewring and arranged by Pople.

7 A comprehensive pictorial history is available on:
www.its-behind-you.com/gallery611.html

8 An extensive correspondence between some of history's most famous actors and the Bristol actor-manager family of the Macready/Chutes is housed in the Theatre Collection at the University of Bristol. Digital images of more than a hundred previously uncatalogued letters written to members of the Macready/Chute family between 1797 and 1937 can be viewed online via the Theatre Collection's website www.bris.ac.uk/theatrecollection

In the Bristol collection, a number of documents relating to Desmond Chute can be found in papers donated by Colin McFadyean in 1993, formerly the property of Lady McFadyean, daughter of Charles Kean Chute. TCW/C/000169/111-128. From two of the letters it seems that Colin knew Desmond well and visited him in Rapallo 1937. One of the theatre's most famous 'associates' was Nipper the dog (born 1884, died 1895) whose owner Mark Henry Barraud worked as a scene painter in the theatre. Nipper served as the model for the painting *His Late Master's Voice* that later became identified with a number of audio record companies, most famously 'His Master's Voice'. There is a small statue of Nipper above the doorway of a building at the junction of Park Row and Woodland Road in Bristol, opposite the site of the

theatre, of which only a single stone column now survives.

9 Merritt, Douglas, *Sculpture in Bristol* (Bristol: Redcliffe Press, 2002) p.44. The death of Abigail's husband was mentioned in *The Times* on 16 February 1912, and again five days later when the funeral was held and 'Jimmy' was buried in Bristol's Arnos Vale Cemetery:

Sir Herbert Tree, Mr. Bourchier, Mrs. Vanburgh, and other leading members of the theatrical profession sent floral tributes on the occasion of the funeral at Bristol yesterday of Mr. James Macready Chute, proprietor of the Prince's Theatre, Bristol. The Theatre Managers' Association also sent a wreath. The procession passed through crowded streets to the cemetery, where many local institutions were represented. [*The Times*, 22 February 1912]

10 Mary de Rachewiltz, *Discretions* (London: Faber, 1961)

11 John Rothenstein (ed.) *Stanley Spencer the man: correspondence and reminiscences* (London: Paul Elek, 1979) p.16.

12 Cited in John Rothenstein, p.17. As with Stanley's estimation of Chute's age, he tended in this set of notes to somewhat dramatise his memory of first meeting the young intellectual. Chute was twenty years old at the time and, according to a factual note sent to the Raverats, Stanley first met him as he was on the way to the Hospital Stores (Stanley to Raverats, undated, cited in Kenneth Pople, *Stanley Spencer: a biography* (London: Collins, 1991) p.110. There were close ties between the Prince's Theatre and the Beaufort, with many actors and visiting artistes giving their time to entertain the troops in the large auditorium at the Hospital.

13 Stanley to the Raverats, June/July 1916, TGA 8116.61. Jacques Raverat (1885-1925) was a painter and wood engraver who studied at the Slade in 1910; his future wife Gwendolen Darwin (1885-1957) also a painter and engraver studied at the Slade two years earlier.

14 TGA 733.3.85

15 One of Bristol's most long-standing bookshops, George's, is mentioned in Letter 4a, 10 June 1916. Eric Gill later designed the lettering for the façade of one of Bristol's best-known independent bookshops owned by Douglas Cleverdon (1903-1987) whose first published book (a collection of engravings) was by Gill. He also later produced a *Book of Alphabets* for Douglas Cleverdon. See John Sansom, *Written between the lines: a memoir of Redcliffe Press* (Bristol: Redcliffe Press, 2006).

16 Letter 21, 8 April 1917. Founded in 1906 on the wave of Post-Impressionism that spread through English art circles, the Clifton Arts Club still thrives and, along with the Royal West of England Academy, is an enthusiastic supporter of painting, printmaking, drawing and sculpture in the city and region.

17 Spencer to Florence Image, TGA 733.1.716-764 John Rothenstein cites another letter: 'Together he completely [satisfied] what of spiritual life I could have. Took me to hear good music. Read – translating fluently as did so Oddysey, [sic] etc. Wrote marvellous letters full of wonderful atmospheres'. Cited in John Rothenstein (ed.)

Stanley Spencer the man: correspondence and reminiscences (London: Paul Elek, 1979) p.17.

18 Stanley to the Raverats, possibly June/July 1916 from Tweseldown, 8116.61, Kenneth Pople cites this letter as dated 13 May 1917. Of the group of Clifton hostesses that Spencer met in Bristol only a little is known. Amy Krauss was an established potter with kilns in Whiteladies Road. The Misses Daniell were a mother and daughter duo enthralled by Baroque music. Mrs Press's husband was from a well-known family of solicitors. Pople (in private correspondence to the author, 2006) further suggests that 'Miss Smith' occupied The Manor in Clifton, one of the most prestigious addresses in the city and now a private clinic. See also Kenneth Pople, *Stanley Spencer: a biography* (London: Collins, 1991), p.112. Spencer wrote to his sister Florence about how he felt 'crackey' with delight to hear duets out of *Figaro* and 'heaps of early French things' sung by the Daniells on his free 'half-days' (Spencer to Florence Image, TGA 733.1 716-764).

19 Stanley quoted in Carline, Richard, *Stanley Spencer at War* (London: Faber, 1978) p.57. A key influence on medieval thought, amongst the philosophical interests of St Augustine (354–430) was the nature of man within a Christian framework. The oft-quoted phrase may be a paraphrase from St Augustine's *Confessions* and is usually cited in works on Spencer as: 'ever busy yet ever at rest, gathering yet never needing, bearing, filling, guarding, creating, nourishing, perfecting'.

20 Kenneth Pople, *Stanley Spencer: a biography* (London: Collins, 1991) p.113.

21 Spencer quoted in Carline, Richard, *Stanley Spencer at War* (London: Faber, 1978) p.56.

22 Spencer to James (Jas) Wood, 26 May 1916, TGA M 19. A life-long friend of Stanley, Jas Wood (1889-1975) was a self-taught painter and writer, with a specialist interest in Persia.

Kenneth Pople writes how St Augustine's writing provided the key to the redemption Spencer so desperately sought, and how it revealed to him the dedication necessary for his future existence as a painter, 'the sacrifice of himself to the spiritual sources of his art' and his destiny as a 'mediator between God and Man', themes which would permeate his writings from then on. (Pople, p.113)

23 Spencer to James (Jas) Wood, 26 May 1916, TGA M 19.

24 Walter Shewring, 'Desmond Chute, 1895-1962', *New Blackfriars*, Volume 44, Issue 511, pages 27-36, January 1963, p.28.

25 TGA 945.46. Amidst the bleakness there were moments of lightness at the hospital. Spencer wrote to a Nurse Higgs (ex-Beaufort Hospital) in 1927 to say: 'In spite of the strain and general nervous tension at that time, nevertheless there was something wonderful in our states of mind, how bright and full of fun we were … Gil[bert] is as rosy faced and robust and big as ever, and I am just as little.'

THREE

Leaving Bristol

✳

FOURTEEN OF THE LETTERS THAT MAKE UP THE SPENCER-CHUTE correspondence were written from one of two transit camps in southern England, the first in Devonport, near Plymouth, and then from a training camp on the Surrey-Hampshire border.

Although Spencer had applied for overseas duty in late autumn 1915, it was not until late spring the following year that he finally left the Beaufort. On 12 May 1916, as the British Expeditionary Force in France went into its final preparations for the 'Big Push' on the Somme, a small draft of twelve volunteers left the asylum-cum-hospital gates for the last time. Spencer wrote to Chute about his mixed feelings as he swept the ward for the last time with his 'chum' George Saunders who was staying behind. 'I felt a bit sad,' he wrote in his customary hand, 'poor old George was so upset.'

Although destined for the RAMC Training Depot near Farnham, Spencer's draft was sent first to Devonport where for two days he had to withstand the customary vicissitudes of servicemen in transit. He and his fellows were not on any ration list, had not been indented for, and were shunted from queue to queue. Having to forage for themselves they eventually found sleeping quarters in a deserted schoolroom nearby. It was rather bewildering but, as always, his letters to Desmond mask any unpleasant tasks or inconveniences, focusing instead on the natural wonders that were revealed to him. Always a keen observer of nature he was moved by his first impressions of the coast, after all this was only his second ever sight of it:

> I did not realize I was looking out across the sea till I saw a ship up
> in the clouds & came to the sensible conclusion that the sea was
> under it.[1]

To augment this description, this letter contains the first of the drawings that were to appear on many of their pages – a small annotation of clouds and a more worked sketch of a conical-shaped tree, which is rather finely seen but which clearly disappointed Spencer: 'Nothing like it,' he writes in an unusually self-deprecating manner.

Over the page there is a small rather dense drawing of a cliff-edge and a free-standing stack of rock, mirrored exactly in clear seas, and likened by Spencer to lines in Homer's *Odyssey*. By the time he resumed this letter his small detachment had been shunted eastwards to Aldershot. Spencer seemed happy to have left 'loathesome tidied patched-up Plymouth', with its 'plastered-round "finished" feeling' and returned to what he considered the quintessential 'Mellow old England' replete with red brick buildings, red earth and green, verdant fields, 'not brown' like those he was glad to leave behind in the south-west.

Tweseldown Camp was to be his home for a little over ten weeks. Just south of Fleet in north-east Hampshire, and not far from Aldershot, the temporary camp consisted of rows of identical wooden huts erected across flat land that had been bought during the Crimea War for military use. In 1867 a racecourse was laid on the site and it gained official recognition as a National Hunt race course a dozen years later. It was occasionally used for reviews of troops based in the area, the Queen visiting it several times, including one huge event in July 1866 when she took the salute of a Royal Review of some 15,000 troops. In 1914 it became the training camp for the Royal Army Medical Corps.[2]

Much of Spencer's daily work was standard infantry training consisting of lengthy route marches through town and country, often in full pack, occasionally accompanied by drums. Contrary to expectation, Spencer thrived on the physical rigours of military training, greatly enjoying the long and arduous route marches, and even the rather 'foolish risky' gymnastics that were part of the Swedish Drill (a form of open-air gymnastics). He described the novelty of his haircut in one letter as 'clipped right close' like a convict, but assured Chute that 'in fact I feel like a rejoicing criminal'.[3] Faced with the task of hauling large wagons, Spencer

exclaimed (without any hint of irony, which is totally absent from his writing) that 'It was perfect. I felt as if my soul would burst for joy.'[4] After the stuffiness and lethargy of the hospital, Spencer thrived in the open air of early summer and warmed to the novel banter of the NCOs, though as ever he was wary of the occasional brutish sergeants who he felt were out to 'crime' him. Always wary of authority, he complained to Desmond that:

> I am not brazen faced and I shall never be able to stand the bullying of these sergeants. At least I shall stand it but it will always hurt me, always shock me. It is useless to say to myself 'ok they are ignorant etc'. Do you know what it is to be watched all day persist-ently by a sergeant who is trying to crime you.[5]

In June 1916 Spencer enjoyed a weekend's home leave, arriving without warning at Cookham and surprising them all with his cropped hair and out-of-doors vitality. It was the last time he would see Sydney, his favourite and most cherished brother, who was to die on active service a week before the Armistice. In subsequent letters to Chute, Spencer remembers with deep affection the layout of each of the trees in the bottom of the garden, recalling the 'William Pear tree', 'the laburnum' and so forth, comparing those happy memories with a recent thunderstorm near Aldershot when lightning had struck a tree studded with metal nails, killing a lance-corporal of 'V' Company.[6]

Ever restless and ready for new challenges, by mid-June he craved training in the specifics of his role, something more fitted to his future job as a stretcher-bearer and he looked forward to night manoeuvres when he might have to go looking for wounded in the dark. However, more basic duties prevailed and he found himself digging latrines, a tedium punctuated only by an immense gathering in the parade ground to take part in Lord Kitchener's memorial service.

It was not until the end of July that 'Special Drill' commenced and much of this was concentrated on managing the water cart and learning the essential craft of water purification. However, each soldier also had a vital lesson in donning and using a gas mask.

Spencer's drawings of the 'insect-like' contraption are very fine, his description of its smell and taste extremely evocative:

> How lovely it is to get a wash afterwards; they are so greasy these helmets & are composed of 2 layers of thick flannelette, greasy & dirty & we breath & suck through a rusty bin tube covered with a piece of transparent India rubbery stuff which you grip with your teeth (you wonder who gripped it last).[7]

Spencer's period of training was rather basic, at times brutish, and often very tedious. It under-taxed the intelligence of often well-educated civilian-soldiers who had eagerly volunteered to make their contribution to the war effort. Only the simulated trench exercises seemed to him authentic, especially when they were enlivened by real danger. As ever, Spencer found the novel exercise stimulating and visually arresting:

> We are still training. We go into the trenches & bring the wounded out. We have to keep our heads down because the captain tells off a party to pelt us with stones if we show ourselves. I love to watch long rows of men in front of me in trenches.
> And the trenches are so solid & sometimes the communication trenches are so narrow that the gassed man we are carrying in his overcoat gets wedged, & it gives me such an extraordinary feeling. When we came out this morning we were caked in clay. Then those ledges you know let into the side of the communication trench. We put our patient there for a rest & it looked fine.[8]

However, not even these hazardous escapades could arrest his impatience. He found the general air of lassitude, and the complete absence of information about his next move very frustrating, even debilitating. Compared to Bristol, he found his new surroundings to be:

> … jammy & sticky like a tin of golden syrup but that is how Surrey makes me feel. There is something definite, clear & concluded about Clifton & thereabouts, but it is just morbid & to me the essence of

Melancholy, a kind I used to enjoy. You see Desmond I feel so disturbed unsettled & sometimes desperate about what I am going to do. If I was in a place where I had got to stay for duration of war I might be able to collect myself, but when you are told you will be away in 10 days you can't settle down at all.[9]

His frustrations were exacerbated by news of success on the Western Front in France (the storming of Pozieres by the Australian Division at the end of July 1916) and the sight of large detachments of his fellows – 'in sun helmets & the lovely cool 'drill' suits' – preparing to leave, 'their dull training' come to an end.[10]

Eventually, his turn came and in August 1916, having made out his will as required by military law and guessing they were heading for 'the east' somewhere, he sorted his belongings, sent home a number of books too large to carry – amongst them several bulky volumes of Shakespeare – and carefully packed *The Canterbury Tales, Crime and Punishment*, the pocketbooks of fine art reproductions published by Gowans and Grey, and other books that had been sent so diligently by Chute.

By late August he was at sea. After the carbolic grimness of the military hospital and the inertia of Tweseldown, Spencer was greatly excited by the sights he saw from the troopship as it steamed up the Mediterranean. 'It makes me tremble down in my inside,' he wrote to Chute, 'every time I look at yonder coast.'[11] His letters teem with exotic sights; of great sandy mounds on the Tunisian seaboard, a coastline dotted with white buildings that seemed to be palaces or mosques, and peculiarly shaped hills 'like the wrinkles on the back of a bullock's neck – most wonderful'.[12] In another he described the view of the Algerian coast as quite mysterious: 'It was just like being in the Bible. Now it is a white ghost-like sea with a dark dusky blue horizon which clears towards the top & the mountain tops appear above.' At some point in the Mediterranean, he and his brother Gilbert 'dipped flags' when their ships passed on their separate ways as Gilbert sailed off to join the Expeditionary Force in Egypt.

Macedonia: a living Quattrocento

Arriving at the free port of Salonika Spencer was posted up country to 68th Field Ambulance on the Doirian Sector. Travelling north-wards, he was immediately enraptured by this new world. The land-scape of whitewashed buildings, solitary peasants, goats and donkeys, tall cypresses and deep ravines was both unusual but familiar, reminding him of the early Italian paintings that he had studied so earnestly at the Slade. The impact was profound. It was as if the two-dimensional visions of his youth had become tangible reality. Once-imagined Biblical landscapes had found their proper Renaissance setting:

> I sat on the wooden seats [of the troop train from Lembet] & was entranced by the landscapes from the window. Low plains with trees & looking through trees to strange further plains, or fields, & here & there a figure in dirty white. It was not landscape; it was a spiri-tual world.[13]

Despite his initial enthralment Spencer's home-sickness could not be dispelled, and on occasion he pined for 'an English sunrise',[14] and, as ever, he worried for his artistic sensibilities:

> Desmond, it is awful the way I am suffering, being kept from my work like this. It will not I think do me harm but it is exasperating.[15]

As expected, given the harsh punishment for sharing military infor-mation, there are few references to his military activities or his work as a medical orderly. He would leave it until after the war to tell those stories, filling his extensive notebooks with tales of his arduous work, not as a stretcher-bearer close to the lines (as he had once thought to be his mission), but to the much less heroic task of transferring the wounded to the cumbersome travoys.

The travoy, or *travoi* (to use its proper French spelling), was a sort of mountain sledge, a mule-drawn contraption comprising two wooden shafts steel-tipped at one end, onto which precarious frame was strapped a canvas stretcher which held a single wounded soldier

who was half-pulled, half-dragged to the dressing station. As a consequence of this controlled dragging (which was both uncomfortable and ungainly) the casualty invariably slid to the foot of the stretcher, jolted there by the treacherous conditions of the tracks and by the vagaries of the mule, which was led by an Army Service Corps driver. Spencer's only option was to support the casualty by gripping him under the armpits, but his short stature made this an exhausting method and it did not always prevent the invalid from being pitched headlong onto the stony ground. The obstinacy and unpredictability of the mules caused further untold annoyance. Spencer complained that his arms used to ache while trying to pull the mules around to prevent them from lying down and falling into a deep (and rather unmilitary) slumber.[16]

In September 1916 Spencer's unit had to support the failed attack on Machine Gun Hill.[17] It was Spencer's first experience of battle. His orders were to help evacuate the British wounded to the dressing station in the abandoned village of Smol about two thousand yards behind the front line. Usually by night, he had to accompany stretcher-bearer parties of some ten or twenty orderlies into the Sedemli Ravine, one of many riverbeds cut into the face of the hills north of Kalinova. There, they would meet the regimental stretcher-bearers who brought down casualties from the front-line, a routine that was accompanied by the curious 'clanging sound' of the travoys dragging along the stony ground, like bars of steel being knocked together.[18]

Nothing of these ordeals is directly mentioned in the correspondence to Desmond Chute, largely because he felt it would not have been of interest to him, but mainly because it would have been censored. 'I must reserve all descriptions till I get back.' wrote Spencer guardedly in autumn 1916. Soldiers were warned against mentioning anything that, if captured, might be construed as having military value to an enemy, although officers were given no such explicit instruction and it was they who read and censored the men's letters. Instead, Spencer agonized about his inability to make paintings:

Oh how I long to paint! A man told me that Malta possesses many old churches full of frescos, & one in particular called the church of St Paul, which contains the life of St Paul on its walls. When this man told me this I began to long. I could not help thinking what a glorious thing it was to be an artist; to perform miracles, & then I wanted to work & couldn't. If I see a man putting a bivouac up beautifully I want to do it myself.[19]

In an indication of how little was happening on the malaria-infected front, he was reading voraciously and asked Chute to send him anything by Hardy, and more by Milton, Shakespeare and Dostoyevsky – books that dutifully (and rather miraculously given the conditions at that theatre of war) arrived by the time of his next letter in November 1916, amongst them 'The Mass Companion, Keats, Blake, Coriolanus, Michaelangelo, Velasquez, Claude' as well as a box of chocolates.[20] Throughout those days with the Field Ambulance on the Doirian Front, Spencer's letters are regularly sprinkled with fond memories of Bristol, of 'those songs' that Miss Daniell used to sing, of Miss Krauss's studio, and of the social gatherings with Desmond's circle of ladies. 'By jove I shall not forget those times,' he had written in October 1916, and again in May 1918 recalling how Bristol 'has a great hold on my mind'.[21]

Throughout the entire rather sorry Macedonian campaign, the enemy seemed not to be the Bulgarian and German troops holed up in their mountainous northern strongholds, but the widespread outbreaks of malaria which laid waste the Allied troops stuck in the insect-ridden plains of the broad river valleys. Spencer was smitten several times, each recurrence further debilitating him and reducing his already poor resistance to this most virulent of maladies.

Spencer changed units several times during his service with the RAMC in Salonika. Such changes – brought about by periods of illness and hospitalisation – were unwelcome to every soldier; friends were lost, equipment displaced, rations refused. It caused Spencer real distress: he was highly dependent on familiar routines and any sudden change disoriented and troubled him for some time. In December 1916, barely two months since arriving in Salonika,

he had to spend a short period in a field hospital, from whence he was posted to a different ambulance unit. By March 1917, he was again in hospital with a recurrence of malaria bought on when nasal catarrh developed into bronchitis. Upon his release he was again posted to a different unit, the newly formed 143rd Field Ambulance, where his role seemed to be little more than to 'round up mules, young ones, fresh, alert eared, that were here & there breaking away & striking out on their own.'[22] Although Spencer's untested unit had been sent to a relatively quiet part of the front it was neither easy nor safe work: on one occasion they came under artillery fire and he witnessed the extraordinary sight of a sun-lit rose bush pulverised into a cloud of dust by the direct hit of a 'dud' shell. At least in hospital, Spencer found time to read and draw. One letter from January 1917 is written on 'British Red Cross and Order of St John' headed paper:

> I am so keen on drawing patients that I spend my whole time on it. This is really how it is that I write so seldom. I believe my drawing is getting more definite; it begins to mean something. Though it is still exasperating. I do anything for these men. I do not know why but I cannot refuse them anything & they love me to make drawings of photos of their wives & children or a brother who has been killed. A diary of a man who was killed chronicled the weather day after day / & as you read these monosyllables it gives you an intensely dramatic feeling.[23]

However, little was going well with the Allies' military campaign. A spring offensive failed and Spencer's new unit was moved eastwards to another river valley, the Todorova. His reputation for being 'artistic' earned him the distinction of decorating the doors of the latrines. He was required to paint the letters that indicated the men's and the sergeants' cubicles, and he 'tried his magic' by marking the latter with a 'big letter S for Sergeants & painted some dog roses round it'.[24] During his convalescence in spring 1917 he composed a remarkable piece of extended recollection of his home village. It comprises several thousand words in the present tense, written as

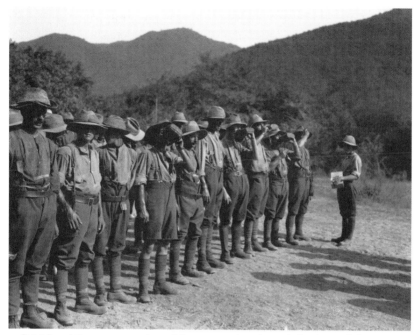

British soldiers on parade waiting to receive their daily dose of the anti-malaria drug quinine, in Salonika. [Imperial War Museum]

if he were taking a prolonged stroll through Cookham. Could it have been done in a state of quinine-induced delirium?:

I go down stairs, and takeing a towel I strole into the street. I walk down to the bottom of the street and call a friend, we all go down to Odney Weir for a bathe and swim. My friend has an Airdale terrier, a fine dog with magnificent head neck and shoulders. He jumps leaps and bounds about in the dewy grass. I feel fresh awake and alive; that is the time for visitations. We swim and look at the bank over the rushes I swim right in the pathway of sunlight I go home to breakfast thinking as I go of the beautiful wholeness of the day. During the morning I am visited and walk about being in that visitation.[25]

By Easter Sunday April 1917, Spencer was writing from the YMCA canteen as he was again shunted from one unit to the other, feeling doubly irritated at not having his customary seasonal treat,

complaining to Chute that 'When we were at home we used to sit round the dining room table & each one of us had a big hot-cross bun for breakfast.'[26]

Fighting man

By the time Chute received the next letter Spencer had lost patience with the Field Ambulance. Spurred on by notices asking for volunteers to join the denuded infantry he had transferred to his county regiment, the Royal Berkshires. And so he embarked on the second phase of his personal trinity – medical orderly, soldier, patient – and this phase would definitely be the most hazardous.[27] He manned outposts, went on the occasional patrol, and was marched hither and thither with often no idea why or where he was being sent. By day he performed the menial tasks so fittingly known as 'fatigues'; a daily grind of carrying, fetching and humping provisions and siege-equipment, but at all times keeping low and concealed. By night he set off for the outposts – 'new moon-shaped ruts in the ground' – and patrolled the wire. It was hazardous but often quite thrilling work:

> We formed up, in the evening just before sunset, outside the dugouts… taking two bombs each from a box as we did so. It was always suspected by the Bulgars as being the time to start a barrage…. The shells dropped uncomfortably near and I was glad when … getting to the outposts, we were able to take cover in a communication trench.[28]

Although there is no mention in these letters, nor in much of the correspondence attempted by Spencer during this final year in Macedonia, there is no doubt that it was arduous, often dangerous work. His lowest point came in the autumn attack of 1918 when he and his fellows gathered to take an enemy line that had previously repelled a charge at the cost of a thousand British casualties. Spencer's moment of reckoning as a soldier had come. 'I did not relish the prospect' he later recalled:

> As I thought what, in an hour and a half's time I should be experi-

encing it seemed to me inconceivable what would or might be happening to me ….

There was the most glaring fact staring me in the face that the place where yesterday if I had shown myself beyond the second belt of barbed wire for ten minutes in the dark, would have got a machine gun bullet through me and where shrapnel was almost a continuous occurrence. And here we were, who for two and a half years had not dared to make hardly one change at all in our front, going to suddenly calmly tread over our wire & over the Bulgar lines right bang in amongst them. … I felt a kind of disagreeable gloominess & taciturness settle on my spirits as the night wore on.[29]

That night, during a short rest, letters from home were distributed. To add to his confusion, Spencer received a note from his artist-friend Gwen Raverat congratulating him on his 'appointment' as an Official War Artist. Rumours of this possibility had been mentioned in various letters many months earlier [30] but it had come to nothing. Spencer was aware that other painters – some of whom he knew – had been called on to become government-funded artists and he had been disappointed at the lack of official recognition. So this 'announcement' from Gwen was doubly confusing, especially in the traumatic surroundings in which he found himself.

But suddenly and without warning the dreadful prospect of fighting lifted: the Bulgars had withdrawn, indeed had apparently vanished. Spencer's sense of release was palpable:

I looked curiously about the ground in front of me which I had only ever seen in the darkness of night. In the night I had gazed and strained my eyes to see what some object was on the left, and now I could see that it was just the straggling remains of a tree and the slight rise of ground on which it stood. Away to the right, the two hills, one bigger, one smaller, [these were the Grand and Petit Couronnes] which had presented such an eerie appearance at night when the Bulgars had been sending up Very lights, looked just another bit of Macedonian country now. [31]

This sudden withdrawal by the enemy was a prelude to the eventual collapse of the Bulgarian Army as they were chased and harassed through the mountains by British and Allied troops. The Berkshires were in the vanguard of this action and Spencer was to come under direct fire a number of times, but he saw out the Armistice in hospital having suffered a relapse of the malaria that had by now spread as an epidemic through the British forces.

Sensing the war was over Spencer began honing an idea for a painted memorial scheme. The promise of an official commission had whetted his appetite and although it would prove elusive it helped focus his thinking, as he explained – in a quite beautiful passage – to Chute:

> If I get this job, I shall be able to show God in the bare 'real' things, in a limber wagon in ravines, in fowling mule lines. I shall not forget what you said about God 'Fetching & carrying', it was something like that, out of St Augustine's confessions.[32]

Could he have known that this would lead to a decade of work on the memorial chapel in Burghclere?

By the closing months of the war Chute had left Bristol to join Eric Gill in Ditchling. Although the correspondence continued Spencer was quite exhausted, so weak he could barely manage simple tasks such as carrying blankets. His recent front-line traumas had almost undone him, and he confessed to Chute that his recent 'experiences seem to have quite unmanned me.'[33] There are, though, flashes of anger, aimed at his straitened circumstances and the inequalities that faced the working man:

> There ought to be an equal distribution of Labour,' he ranted at Desmond, in an untypical political broadside, 'if any man is ignorant or fool or knave, you & I are largely responsible.'[34]

Spencer returned to Cookham by train through Italy and France, and troopship into Southampton. Coming home after years of tribu-

lations and nagging illness was like being reborn; it was another moment of personal and symbolic resurrection that would soon find its visionary form on the walls of the chapel at Burghclere. Across its magnificent end wall he would paint a vast Resurrection of the Soldiers, re-imagining all those whom he had laid gently into the earth during the many burial parties he had taken part in on the Salonika front. Years later he reflected how the very crossing of the English Channel had triggered such a premonition to him:

I think I have been led to do the Resurrection subject through this sense of true meaning of things. I used to say 'today is the world to come' meaning that it contained as much & could express as much as that. I had a sense of this being born again; of approaching the 'world to come' when I was returning from Macedonia after all the years out there & never expecting to return. As I approach the light-house off the Isle of White in the dark & the light swinging round & round now on our ship now not; its wonderful. I 'the unborn babe' still in the ship – am having a little chat with a sort of angel who is giving me advice & some notion of what this life of mine in England is going to be like. In this imaginary converse I now & then get a little concerned at the future possibilities being foretold & raise my unborn eyebrow & say 'nothing precipitate I hope?' [35]

Notes

1 Letter 1, postmark, 12 May 1916

2 For further information about the history of Tweseldown as a training ground and as a racecourse see *Hampshire Treasures*, Volume Three (Hart and Rushmoor), p.24, available on www.hants.gov.uk/hampshiretreasures/

3 Letter 2, postmarked 12 May 1916

4 Letter 2, postmarked 12 May 1916

5 Letter 10, page one, summer 1916

6 Letter 4, received 10 June 1916. For an artist long reckoned to freely 'wear his heart on his sleeve', Spencer wrote very little to others about the tragic death of Sydney, some losses being just too crushing to share. Sydney's diaries, now held at Berkshire County Records Office, Reading, demonstrate just how close these two brothers really were.

7 Letter 8, received 24 July 1916

8 Letter 12, summer 1916

9 Letter 8, 24 July 1916

10 Letter 9, 26 July 1916

11 Letter 15, August 1916

12 Letter 15, August 1916, accompanied by a small drawing

13 Notebook 1945-47, TGA 733.3.86

14 Letter 16, autumn 1916

15 Letter 16, autumn 1916

16 There were other variations on the 'travoy': the 'doolie' required the shafts to be slung between two mules, and was used to overcome marshy ground. The cacolet (or 'cacklet' as the British troops called it) was a customised chair slung either side of the mule in a rather haphazard, even hazardous, fashion. Spencer depicted this type in one of the arched panels at Burghclere.

17 The attack on Machine Gun Hill is told in Paul Gough, *Stanley Spencer: Journey to Burghclere* (Bristol: Sansom and Company, 2006) pp.67-71.

18 Spencer to Henry Lamb, 20 July 1917, TGA 945.37

19 Letter 17, 28 October 1916

20 Letter 18, November 1916

21 Letter 22, 25 May 1918

22 Notebook, 1945-47 TGA 733.3.86

23 Letter No. 19, 4 January 1916, this should be 1917 (see earlier endnote 6 in 'Meeting Desmond')

24 Notebook 1945-47, TGA 733.3.86

25 Letter 20, March 1917 page 4 recto. As Ann Danks has observed, the Airedale terrier belonged to Cookham resident Guy Lacey (who taught Stanley and his brother Gilbert how to swim) and can be spotted in the foreground of Spencer's 1920 canvas *The Bridge* (N05393, Tate Collection). Ostensibly a picture about spectators watching a boat race, the painting has a strange haunted quality, the figures

are rather lifeless, even inert. As Ann Danks has suggested it is 'a very moving, nostalgic painting which resounds of loss bought on by the war.' As such, it has much in common with another post-war painting by Spencer depicting the unveiling of the Cookham War Memorial where lines of young men – equally pale and spectre-like – seem like a parade of the surrogate dead returned to their village to receive the tribute of the living. See Paul Gough, 'Dead Troops Talk: reviving the dead in the work of Stanley Spencer, Will Longstaff and Jeff Wall', in *Deathscapes: New Spaces for Death, Dying and Bereavement* (Eds. Avril Maddrell and James Sidaway) Ashgate, 2010, pp.263-281.

26 Letter 21, 8 April 1917

27 'At last,' he wrote to his sister Florence (Flongy), 'I am back up the line'. TGA 756.34.

28 Spencer to Florence, 24 February 1918, TGA 756.34

29 Numbered writings 1936, TGA 733.2.25. Years after the war he recalled the dangerous topography of his outpost on M4 Hill in a page of one of his sketchbooks. TGA 733.3.81

30 Letter 22, 25 May 1918

31 TGA 733.3.85

32 Letter 22, 25 May 1918

33 Letter 24, 5 October 1918

34 Letter 23, 16 September 1918

35 Spencer to Daphne Spencer, letter no. 4, January 1951, cited in Jeremy Harvey, 'The Stanley Spencer–Daphne Spencer Correspondence'.

After the war: a parting of ways

✽

ALTHOUGH SPENCER AND CHUTE MAINTAINED A CORRESPONDENCE IN
the months after the Armistice, their paths were diverging and their
careers changing. Despite his hardships Spencer recovered quickly
from the war and was soon painting his large canvas for the govern-
ment's memorial scheme. While he camped out in a temporary
studio in nearby stables in Cookham, Chute was pondering whether
or not to stay in Ditchling, choosing his moment to part company
with the artistic community that had gathered around Eric Gill. In
1921, after much consideration, he moved to Switzerland to begin
his long training for the priesthood. There is though little doubt
that Desmond's time at Ditchling had been deeply transformative.
In 1926 he recalled:

> At last I feel that I have somehow come to live not as an onlooker,
> nor as a man at my particular job, but as a man among men. A
> simple thing, not worth chronicling – but a thing uniquely difficult
> to me.[1]

It is fascinating to think of Desmond learning his trade as an
apprentice carver while Spencer was busy working on his war
painting, all the while nurturing his ambition to create a memorial
scheme that recalled his time in Bristol and the Balkans. In fact, as
Spencer was evolving memorial compositions in his expansive imag-
ination, Chute was actually helping Gill with the creation of his war
memorial for New College Oxford. Regarded now as an iconic piece
of memorial architecture, Chute's contribution may have been
modest, after all, his carving skills would have been basic, but his
ability to draw and design in outline was sophisticated.[2]

Chute was ordained in 1927, just as Spencer began work in the
memorial chapel that had been commissioned by J. 'Louis' and Mary

Behrend and designed by Lionel Pearson for the Hampshire village of Burghclere.[3] While Spencer began his five-year-long residency in the chapel, Chute – dogged by indifferent, often poor, health – moved to north-west Italy where he settled as a priest in Rapallo, a coastal town in the province of Genoa.

Their correspondence, once so intense, once a vital lifeline between the two men, tailed off, even becoming rather formal, almost business-like after the war. One reason for this sudden cooling in their relationship was an episode in early 1919 when Spencer was invited to Hawkesyard Priory, the Staffordshire priory of the Dominicans, to see Eric Gill and Desmond Chute 'clothed' or inaugurated as Tertiaries in the lay order. Both men harboured an ambition to convert Spencer who, as was clear from his recent correspondence, had considerable sympathy for Catholicism. 'I have written to Stanley Spencer,' explained Gill to Chute on 11 January 1919, 'to suggest his coming to Hawkesyard with us on Saturday... His last letters show his need of "hard task" in the way of theology.' Unfortunately, on the eve of their departure from Euston, Desmond was smitten by the dreaded influenza that was then ravaging Europe and Abigail, fearful that he would be fatally struck down, gathered him from Sussex and had him chauffeur-driven, swathed in blankets, from Gill's base in Ditchling home to Bristol. Despite some misgivings Spencer went on alone. In a postcard of 20 January, from Hawkesyard, Gill wrote of having 'some sport':

> We are here and Stanley Spencer is with us having a fearful wrestle, chiefly with himself. He met us at Euston on Saturday determined not to come after all – but we persuaded him and he came just as he was – with his hands in his pockets & no luggage at all. What will be the upshot of it God only knows – he is in a curious mixed state of pride, prejudice & humility and reverence.[4]

Although Spencer put a brave face on it (writing to Desmond on 25 January that he 'had a good time at Hawkesyard' but had 'counted on seeing you') he had in fact been traumatised by the encounter, confiding in others that the weekend had been 'hell'. Spencer did not like Gill and

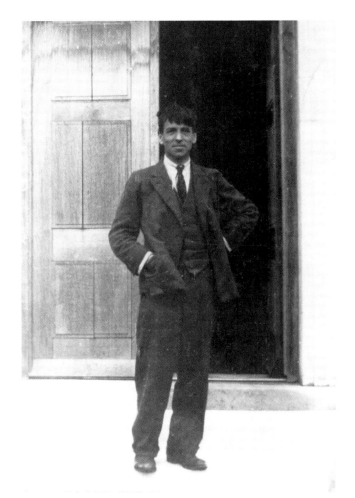

Spencer outside Sandham Memorial Chapel

rejected Catholicism. His experiences of war 'made the concept of a personal God difficult for him'.[5] Chute returned to the communal workshop at Ditchling, Spencer went back on his own to Cookham.

Feeling betrayed and jealous of Desmond's new affiliations Spencer recognized that the intensity of their wartime friendship could not be rekindled. This was the first time that a person he worshipped as essential to his spiritual life failed to live up to his expectations. As Andrew Daniels has observed, the painter now realized that he been wrong to believe that Chute was a 'soul mate' sent from Heaven to fulfill a purpose. Chute had indeed enjoyed the

Abigail and Father Desmond Chute

respite of Spencer's companionship in Bristol and had been pleased by his temporary role as cultural and spiritual mentor to Spencer, but rather sadly Stanley now recognised that he was not as 'unique' to Desmond as Desmond had been to him. Gill and the Ditchling group had become rivals for Chute's attention, a rivalry exacerbated by their shared Catholicism, and the Hawkesyard episode ended the one-to-one relationship that Stanley so needed and thrived on.[6] 'I felt the loss,' wrote Spencer with stoic disenchantment. 'Oh, yes, he is a friend of mine as far as I know, and our old esteem and mutual interest is still in being.' However, from then on his letters, that had once ended

The Gill family at Ditchling

'From your loving Stanley' and 'Your loving friend Stanley', conclude with the more formal 'Yours ever, Stanley Spencer'.[7]

Although devoted to his vocation in Italy, Chute was often in England, visiting his mother and his network of friends, including on occasion Spencer and the Ditchling community. There is a very fine drawing of him in profile made by Eric Gill during a visit in 1929. A year later Desmond was again in England to see his ailing mother who was dying of cancer. The following year, Abigail passed away at the age of seventy-six and Desmond commissioned Gill to produce a fine tombstone which can be found in Canford Cemetery, west Bristol.[8] It is carved in Gill's inimitable style with the text:

ABGAIL/PHILOMENA/CHUTE/NEE HENNESSY/WIDOW OF JAS/
MACREADY/CHUTE/ ON WHOSE SOUL/SWEET JESU/MERCY/

While the 1930s brought periods of personal calamity to Stanley Spencer, Chute grew to be an established, quietly renowned figure in Rapallo, becoming an intimate of a succession of writers and artists who settled there in the 1920s and 1930s, amongst them such eminent figures as Max Beerbohm, Edward Gordon Craig, Ezra Pound and WB Yeats. Together with Carlotte De Feo, the opera singer, American concert violinist Olga Rudge and local intellectuals

Desmond commissioned Gill to produce Abigail Chute's tombstone, Canford Cemetery, Bristol

from the Italian community they formed a literary, artistic and musical community known as the 'Circle of the Tigullio', named after the Gulf on which Rapallo stands.

Chute cut a distinctive, if slightly elusive, presence in the town. A fellow resident, Professor Pietro Berri recalled the familiar sight of 'a priest, tall, but of pale complexion, with a beard at one time golden-brown, but latterly streaked with grey. Always sporting dark glasses for the greater protection of his sight' making his way through the alleys 'at a hurried, even scurrying pace, always alone, seldom acknowledging passers-by', invariably making his way to a meeting of the Tigullian Circle. He lived in a comfortable villa, filled with books, musical scores, surrounded by fine furniture and works of art, maintained in a constant state of semi-darkness, 'striving to

shade his weak eyes from the least reflection of sunlight.'[9]

However, Chute was far from being an isolated individual. He was involved in charitable works which drew the support of numerous families, and Walter Shewring (Eric Gill's literary executor) remembered him as 'much admired', even rather spoiled by the great ladies of the Ligurian nobility whose company on occasion he kept, 'but equally devoted to him were the humble bathing attendants on the beach, or the old sailors, or the widows of workmen and shopkeepers whom he visited in their affliction'.[10]

Princess Mary de Rachewiltz, the daughter of Ezra Pound and Olga Rudge, in her 1961 memoir *Discretions* left an affectionate note of the 'English *abbé*' who had settled in a lovely little villa in Rapallo:

> His health was poor, his eyesight very delicate. But his discipline must have been adamant, for he could not otherwise have been such an accomplished and honest dilettante. He did everything with extreme 'diletto' and care, never pretending to be a great artist. … He was extremely reserved; the closest he would come to private communication would be a sigh or a weary smile if his Italian housekeeper brought him a hot water bottle that was not quite hot enough, or if I drew the wrong curtain. We never exchanged a word, other than greetings, and since I never saw his eyes, he remained for me somewhat of a mystery man.[11]

Having to learn long passages from Virgil, Horace and often more obscurely Bossuet's *Oraisons Funèbres* as part of her lessons in French and Latin, she recalled how Father Chute recited them gently, without emphasis, but with 'such inner participation that the stream of words flowed like a clear river.' Concluding that he came from a family with long theatrical traditions 'and it showed'.

Very occasionally Desmond's past in Bristol would coincide with his circumstances in Italy. Having always done strenuous work for good causes, he had helped found the *Apostleship of the Sea* in Genoa and did considerable work on an Italian prayer book for sailors. Invited to present a copy to Pius XI, accompanied by Abigail Chute, he was permitted an audience of five minutes, but 'the Pope stayed

Rapallo

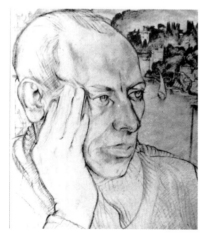

Above, from left, clockwise:
Ezra Pound, Carlotte De Feo and
Mansueto, the beach superintendent.
Sketches by Chute

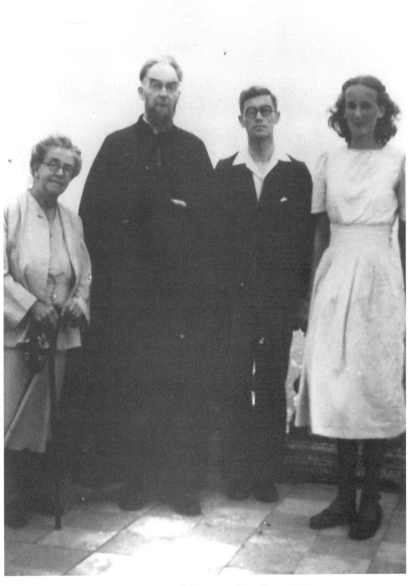

Father Desmond Chute at Rapallo, c.1950.
Left to right: Mrs Mary Gill (Eric Gill's widow); Desmond Chute;
Walter Shewring; Prudence Tegetmeier

for half-an-hour, asking questions about the Apostleship and listening intently to the answers.' Abigail, wrote Shewring, 'kneeled beside him in ecstasy.'[12]

'Of Father Desmond Chute', recalled Eric Gill in April 1940, a few months before his death, 'I shall say little because my love for him is too intimate, too much a matter of daily companionship and discussion and argument, too close a sharing of life and work and ideas and doubts and difficulties – the only man, and therefore the only priest with whom I have been able to talk without shame and without reserve.'[13]

Having been left in peace by the Italian authorities for much of the war, Chute was removed by the German armies for surveillance to Bobbio in the Ligurian Apennines, where he lived and worked in the local hospital. In 1945, as the Germans retreated northwards, he made his way back to Rapallo on foot where 'his art, and especially his music, occupied those parts of his days not dedicated to his priestly duties or his charitable undertakings….an aesthete in the purest sense of the word, whose very gesture revealed a rare fastidiousness, not always concealed behind an unexpected shyness.'[14]

Some twenty years later, on 14 September 1962, Desmond Chute aged sixty-seven, died peacefully after a long illness, only three years after Spencer had passed away. Three days later, as the news was announced in *The Times*,[15] his funeral was held according to his written wishes:

> In reverence and love for the Sacred Liturgy, I desire that my Requiem shall be sung with deacon and sub-deacon; apart from this, let my funeral be like the funerals of the poor. Let me be buried in the habit of a Dominican Tertiary and in all the vestments of a priest. If I do not die in England, let my tombstone bear only the dates of my birth, of my ordination and of my death, and the words:
> Desmond Macready Chute : Pulvis attamen Sacerdos
> Dust – and yet a priest

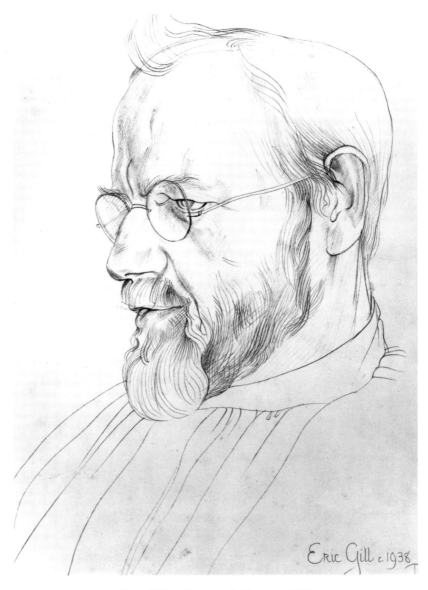

Eric Gill by Desmond Chute, c. 1938.
© National Portrait Gallery, London [NPG3957]

Notes

1 Walter Shewring, a classical scholar and literary executor to the late Eric Gill, as well as resident intellectual in the sculptor's circle, has left the most detailed appreciation, if only nine pages long, of Desmond Chute in his recollections which were published in *New Blackfriars* (January 1963) Volume 44, Issue 511, pp. 27-36. Shewring's handwritten transcripts of the letters are also held in the Stanley Spencer Gallery, Cookham, and have a number of footnotes which helped inform his article in *New Blackfriars* and his earlier edited volume of Gill's letters, published in 1948.

2 'His best portraits,' reflects Shewring, 'are pure line-drawings and are psychologically convincing.' Eric Gill's volume of *Letters* has a portrait of Gill by Chute at p.214, and at p.346 one of Chute by Gill. See Shewring, 'Desmond Chute, 1895-1962', p.28, fn 6.

3 The elaborate story of the commissioning, building and painting of the chapel and its interior is told in detail by Paul Gough, *Stanley Spencer: Journey to Burghclere* (Bristol: Sansom and Company, 2006)

4 *Letters of Eric Gill*, ed. Walter Shewring (London, Cape, 1947). According to the Chute family website, Desmond made at least two visits to Cookham in the 1950s to introduce Stanley to his cousin Dora, by then Lady McFadyean. She later recalled Spencer as 'What a character !!!!' (To Kenneth Pople, 1982, cited in Pople, p.187)

5 Kenneth Pople, *Stanley Spencer: a biography* (London, Collins, 1991) p.185.

6 Andrew Daniels, correspondence with the author, December 2010. For an insightful analysis of Spencer's art see Andrew Daniels, *Stanley Spencer: The Making of a 'Singular' Man: a Study of the artist and his motivation* (unpublished manuscript, 2002, available at the Stanley Spencer Gallery, Cookham). As ever, I am grateful for Andrew's scholarly advice and rich insights into Spencer's mind.

7 His hurt was underlined when, on a visit to Cookham after the Hawkesyard episode, Desmond had shown little, if any, interest in Stanley's new painting, *Travoys*, then commissioned by the Imperial War Museum, but was transfixed by a Crucifixion painting by Gilbert Spencer, 'so staggered', remembered Stanley that he could hardly speak.' (TGA 733.2.370-1) When Chute made a hasty exit from Stanley's chilly stable-cum-studio, the painter realised he had lost a 'once valued handholder'. (Pople, p.186) Chute later bought the Crucifixion from Gilbert, Stanley acting as middleman, arranging the sale and collection in letters to Chute in August 1926. The painting was still hanging in his villa in Rapallo when he died.

8 Abigail Philomena Hennessy Chute's headstone (made of white marble, some 190cms high by 90cms wide) is to be found on the north wall of the cemetery some 100m to the left of the main gate. The central panel in carved Roman capitals reads: ABGAIL/PHILOMENA/CHUTE/NEE HENNESSY/WIDOW OF JAS/ MACREADY/ CHUTE/ ON WHOSE SOUL/SWEET JESU/MERCY/ Left-hand panel 15/ FEBY/1855/. Right-hand panel: 5/OCT/1931 Although buried in Italy, Desmond is mentioned on the left of the central memorial

with these carved words:

DESMOND/MACREADY/CHUTE/PVI.VIS.ATTAMEN/SACERDOS/1927/E
CCE EGOS SERVVS ET FILUS/

The monument is recorded on the Public Monument and Sculpture Association National Recording Project database as Region ID: BL, Work ID: 151, Manual Reference BR139. Spencer may have met with Abigail one year before her death. On 9 December 1930 he travelled to Bristol, ostensibly to refresh his memory of the Beaufort hospital but possibly to meet up with Desmond who was in England visiting his mother who was then in declining health.

9 Professor Pietro Berri, quoted in Kenneth Pople's 'Background to the Spencer-Chute Letters', Stanley Spencer Gallery, Cookham.

10 Walter Shewring, p.32.

11 Mary de Rachewiltz, *Discretions*, (London: Faber, 1961).

12 Walter Shewring, p.32, fn.11. Fiona MacCarthy, who wrote a rather controversial biography of Gill in 1988, has written a detailed account of her working relationship with Shewring in *Lives for Sale*, editor Mark Bostridge (London: Continuum, 2004).

13 Eric Gill, *Letters*, 1947, p.448. This is Eric Gill's last letter to Chute, written 29 April 1940.

14 Professor Pietro Berri, quoted in Kenneth Pople's 'Background to the Spencer-Chute Letters', Stanley Spencer Gallery, Cookham.

15 *The Times*, 17 September 1962.

A note on the correspondence

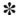

FEW BRITISH ARTISTS HAVE WRITTEN AS MANY LETTERS AS STANLEY
Spencer. Maurice Collis, invited to write the painter's biography in
the late 1950s, was astonished to take delivery of two large packing
cases and a wooden truck on castors, in which were crammed 'not
only notebooks and writing pads of every shape, colour and thickness,
but a multitude of loose sheets of writing.'[1] To compound his task,
there was no list, nor inventory or guide of any kind. In order to
fathom the extraordinary individual embedded in these manuscripts
Collis managed to identify some eighty-eight bulky notebooks, thir-
teen diaries, and over 900 extensive tracts of writing, ranging from
musings scrawled on the back of envelopes to jottings that cover
many pages of his rather urgent script. It is now reckoned the painter
wrote in primary material some two million words. Likening his
output to that of James Joyce, one archivist has suggested that:

> Spencer's writing presents a stream-of-consciousness chronicle of
> his own thoughts and feelings unparalle[le]d both in volume and
> intensity by any artist in the twentieth century.[2]

Spencer's letter writing began in earnest in the early 1920s when
he was busy courting his first wife Hilda Carline. He exchanged
daily correspondence with her, indeed sometimes writing several
times a day. Part of a rich and talented circle of Hampstead artists,
musicians and writers, Hilda offered Spencer an entirely new intel-
lectual circle that in turn propagated new networks of correspon-
dence. But to talk of this part of Spencer's biography is to move
ahead too soon. The letters reproduced in this volume relate to an
earlier period, to a rather traumatic interlude in the young painter's
life that threatened to destabilise him just as he was gaining a footing
in the British art scene. Instead of honing his extraordinary talents

in Cookham and exhibiting in London, Spencer was posted to the teeming metropolis of a military hospital in Bristol. However, as if by chance, wandering into this harsh, unloved grimness came the young aesthete Desmond Chute. Their friendship was founded on shared interests and a mutual love of poetry, music and intellectual company. Their subsequent correspondence, after Spencer was posted first to camps in England then overseas, lasted some ten years and is a rich and intense exchange which kept Spencer in contact with the world of ideas and the arts while on active service.

From the very moment that Spencer left Bristol on military duty, in the late summer of 1916, he wrote to Chute, sprinkling his letters with observations about his new surroundings, the sights in nature that he so revered, and the peculiar companions that worked and slept alongside him, including a cross-eyed carpenter from Middlesborough whose drinking habits astonished the unworldly Spencer. Not wishing to perturb the rather sensitive Chute, Spencer's letters were full of gentle re-assurances, that even amongst 'these "disgraceful characters" one might find the true power of forgiveness.'[3] Also sprinkled throughout these letters are small drawings that convey what might not easily be expressed in words: the strange impression of a sailing ship seeming to float in the sky; the sight of a column of troops marching over undulating land; the difficulty of carrying the wounded through narrow communication trenches, and the recollection of an operation in the military hospital with its graphic description of the incision in the belly and 'all the forceps radiating from it like this…'[4]

However, conditions for reading and writing (let alone composing exquisite line drawings) were rarely ideal. 'Thank you for that beautiful letter' (wrote Spencer in July 1916):

It is impossible to concentrate down here because there is a continual noise. The man who sleeps next to me has a noisy brain, if you know what that is like. I do not get one minute's quiet since I have been here except when I have been home. There are thirty men present when I write these letters to you.[5]

Sadly, there are no surviving letters from Desmond Chute. It is likely that these were amongst the small pile of papers, letters and drawings that Spencer had to leave behind in his kit-bag in 1918 as his regiment prepared to join the final offensive against the Bulgarian army in northern Macedonia. Despite the best efforts of the authorities (including the staff at the Imperial War Museum who later commissioned a painting from him) none of these precious belongings were ever recovered, and he was forced to concede that '... some Macedonian peasant now has my drawings.'[6] There is, however, a powerful sense of conversation between the two men; Chute's voice can be clearly heard in Spencer's responses and a dialogue of deep friendship is ever present as two kindred spirits share thoughts on God, Gluck and St John's Gospel. Chute was clearly a diligent and faithful respondent: Spencer less so, but given his unusual circumstances this is hardly surprising. In November 1916, for example, as Spencer recovered from an abortive attack on Machine Gun Hill, he acknowledged '3 letters from you ... but I will write more properly when I feel more patient.'[7]

As well as writers, composers and the occasional saint, the letters cover a range of diverse topics. Photographs are exchanged – reproductions of architectural corbels are mentioned in letters throughout the summer of 1916, as are parcels of books on Duccio, Donatello and Dostoyevsky despatched by Chute to military camps in England and Macedonia. There is little doubt that Chute was a prolific and reliable correspondent; from Tweseldown Camp in mid-summer 1916 Spencer apologises for not having replied to 'goodness knows how many postcards from you.'[8]

In the later letters, written from the battlefields of Macedonia when Spencer must have felt at his most bereft and homesick, there are some well-wrought reminiscences of Cookham, colourfully populated with a powerful sense of place and character. These highly moving passages are all the more remarkable coming from a young man who was largely self-taught, whose only formal early education had been offered to him and his brother Gilbert by his elder sister in a small potting shed at the back of the family home. Take, for example, the evocative opening paragraph of an eight-page reminiscence

written from Salonika in March 1917:

> I am walking across Cookham Moor in an easterly direction
> towards Cookham Village, it is about half past 3 on a Tuesday after-
> noon and I have just seen mama to the station. Walking up on to
> the causeway between the white posts placed at the eastern end, is
> Dorothy Bailey; how much Dorothy you belong to the Marsh
> meadows, and the old village. I love your curiosity & simplicity,
> domestic Dorothy. I can now hear the anvil going in Mr. Lanes
> Blacksmith shop, situated on the right of the street, & at the top
> end of it, as I walk towards it...[9]

Despite the rapport between the two men there is often a sense in
Spencer's writings that he wrote impulsively, for himself as much as
for the recipient. There are few concessions in style for the reader, there
are frequent meanderings, and some letters even seem to start mid-
sentence. Although the majority follow conventional form, the letters
are mannered by his idiosyncratic style and unorthodox use of
grammar. Yet, as Jeremy Harvey has commented in a recent analysis
of Spencer's writing, Spencer's occasionally peculiar 'grammar,
spelling and punctuation are soon grasped and are no stumbling block
to gathering his meaning.'[10] Vagaries of style aside, this suite of letters
has an unmistakable authority and integrity that can be missing from
some of the painter's later writing. John Rothenstein, in his scholarly
appreciation of the painter's correspondence and reminiscences, offers
a timely warning against over-relying on some of the later letters,
especially when seeking accurate or objective information. Suggesting
that much recent biography had been distorted by an unchallenged
reliance on his correspondence, he warned readers to be 'acutely aware
of the many pitfalls and fallacies that evidence of this kind can
generate', even suggesting that it was too easy to seek truth in a tran-
sitory emotion that had been 'violently expressed' in a letter or the
product of an artist's untypical mood. Concluding his words of
caution, Rothenstein advises that a proper interpretation and evalua-
tion of Spencer's letters demands a 'delicate and scrupulous scholar-
ship and even so will remain a difficult, even complicated business.'[11]

Happily, the correspondence between Chute and Spencer that is reproduced here is not mired by the controversies that hung over the painter in the 1930s and have divided opinion ever since. This 'precious bundle' of letters was found intact by the Classical academic Walter Shewring who had been sent by the family to Chute's home in Italy to retrieve his papers. Transcribed by Shewring himself, they were purchased by the Friends of the Stanley Spencer Gallery, Cookham and then given to the gallery in 1966 in memory of Dorothy Upson, their first chairman. In 1982 Kenneth Pople researched and assembled a small volume of background material to help illustrate the key personalities and offer some historical context. The transcriptions in this book adhere to the customary conventions of presentation, with much of the spelling corrected to help guide understanding, although many mispellings and other infelicities have been retained to give a flavour of the originals. Explanatory notes are used sparingly so as not to overwhelm the reader, but to offer a modicum of contextual material. Some pages that feature drawings or other graphic notes have been reproduced in facsimile.

So to conclude this brief introduction, let us ask: what is the value of these letters? What do they tell us about Stanley Spencer, artist, friend and somewhat hapless soldier? In truth, they are a typical snapshot of the artist as a young man caught in a period of rapid and radical transition; a painter (to borrow a memorable phrase from Elizabeth Rothenstein) moving inexorably (and irreversibly) from being an intuitive artist to an imaginative one, displacing his art's stillness and unity and stimulating a latent 'enquiring and curious side'.[12] Above all, the letters contain some of the key passages in Spencer's biography, bringing fresh insights into our sense of Spencer and how he was being transformed by the experiences of warfare. The letters examined here tell us about his period in military training and his 'release' from the asylum-hospital in Bristol, followed by his tribulations on the battlefields of the forgotten Macedonian front, and then his second release, his personal 'resurrection' from soldier to civilian in early 1919. Running throughout the correspondence is a rich cultural seam of

writers, musicians and poets he had been introduced to by Desmond in Bristol, a rich litany of names that includes Homer, Shakespeare, and Milton as well as Gluck, Mozart and Beethoven.

There are other significant statements and ideas: in one letter he passes damning judgment on the character of fellow-artist Henri Gaudier-Brzeska, in another he raises the spectre of painting his memories of the hospital in Bristol, starting first with a fresco of a surgical operation. Given Spencer's achievements at Burghclere in the decade after the war this was quite a premonition, and it would return to him during his many barren months in Salonika. 'This does not sound much,' he warns Chute, vividly detailing the forceps, the sterilisation and the incision, 'but leave it to me.'[13] Teasingly, there are references in letters from the front, as in letter 17, that predict the resurrection themes on the walls of the Sandham Memorial Chapel, which suggests that Spencer was gestating his grand vision for a memorial scheme at a very early stage in his war.

Less expected are the long explanatory tracts that unravel the workings of a canvas gas mask or the inner mechanics of a cylindrical water bowser. Such procedures stimulated his innate sense of curiosity and fortified his literal and exacting nature. Quite what Desmond Chute would have made of the elaborate detail of water purification one can only guess, but given the alarming incidence of malaria and other water-borne disease on the Mediterranean theatres of war it clearly mattered greatly to Spencer and was drummed by rote into the medical orderlies:

> We have 6 cups, nice clean ones, set in a row & filled with water from tank to within ½ inch of top. 3 drops of testing solution is put in each pot. We have a black pot & a tin full of bleaching powder & a 2 dram measure. We fill black pot up to mark with water & put one little measure full of bleaching powder into it & mix it into a thin paste. We then put 1 drop in first pot, 2 drops in second & so on to the sixth. Then the pots are left for ½ hour. We return when time is up & notice that Nos 1 2 3 4 & 5 are no longer blue & No 6 is not as blue as it was. In this case we should have to empty pots & put drop 7 8 9 10 11 12 respectively into each pot. No 7 would be

the one & we should put 7 measures of Chloride of Lime into it, mix it up & pour it into tank. And behold you have pure water.[14]

There are also a number of musings on the progress of the war itself, observations – about the fighting on the Somme and the storming of Pozieres (by the Australian Division) that refute the easy observations made by commentators who state categorically that Spencer lived his life in a bubble isolated from the historic and contemporary circumstances of which he was part. And, throughout the letters from Hut 3, in D Lines at Tweseldown, there are endless predictions about where overseas they might be posted. Amongst the destinations rumoured in his letters are India, Mesopotamia, and rather more vaguely the Far East or 'the East somewhere'. As he and his troop were often drilled in tropical gear, wearing their khaki gear and sun helmets, they sensed, however, that they would not be sent to the Somme despite the immense scale and insatiable demands of that five-month-long campaign.

One of the recurring themes in Spencer's last letters sent from Salonika was his hope that he would be officially recognised as a government war artist. In May 1918 he had received a formal offer from the Ministry of Information but gaining further confirmation had proved impossible. His frequent changes of unit and shifting address only exacerbated this dilemma. Desperate to return to England, to rid himself of the recurrent malaria that had smitten him time and time again, and ever anxious to re-connect with his creative self, his pleading to Chute (and to other correspondents) brought out some of his most brilliant prose: 'If I get this job,' he wrote to Desmond in June, 'I shall be able to show God in the bare 'real' things, in a limber wagon in ravines, in fouling mule lines.'[15] Sadly, it was not until he reached England in mid-1919 that he could actually take up this commission, producing *Travoys Arriving with Wounded*, one of the most quietly sublime canvases to emerge from the war.[16] Before that release, Spencer had to experience some of the very lowest points of what had, in truth, been an unrelentingly debilitating war experience. In his final surviving letter from the Front Spencer looked his faith squarely in the eye and found it

almost wasted and threadbare. In abject desperation he asked of Chute what he could barely ask of himself:

> Christ has been adequate to me in all things, but is he in this? You must know something of what I mean, Desmond. It is an awful shock to find how little my Faith has stood in my stead to help me.[17]

Surely, in the vast *corpus* of Spencer correspondence, there is nothing so piercingly honest as this. Arguably, it is such searing truthfulness that marks the Chute letters as something very special. Unlike some of Spencer's later rather more self-aware musings, they were not written with any audience other than Desmond in mind. The grim circumstances in which they were written mean that the transitory emotions, the strains of parting and the trials of warfare are expressed with a poignant authenticity that can be missing from later writing. And, significantly, as a tangible body of material held in one place, the correspondence between Spencer and Chute forms a unique and satisfying wholeness that can be held and savoured. The fact that they are not in the immense Tate archive with many hundreds of other documents, accessible only by written application, but survive as a self-contained capsule of correspondence preserved in Spencer's own village, surrounded in the Cookham Gallery by the evidence of his genius, adds immeasurably to their appeal and importance.[18]

Of the thirty-one letters to Chute, two were sent from Devonport, twelve from Tweseldown near Aldershot, one written on board the ship as it sailed through the Mediterranean, and ten from the battle zone in Macedonia. Five letters date from after the war, two written from Spencer's family home Fernlea in 1919, the others from Hampstead in 1926. Three years later the last in this series was sent from Wangford, Suffolk on the eve of the birth of Stanley and Hilda's second daughter, Unity. By the mid-1920s the relationship with Chute had lost its intensity and the mail tailed off. Their letters become more formal, their meetings sporadic, but this only serves to highlight the intensity of the bond that had been tied during the Bristol months and the subsequent lifeline of letters that had sustained both men during the grim months of a long war.

A note on the correspondence

Notes

1 Maurice Collis, *Stanley Spencer: A Biography* (London: Harvill Press, 1962), p.13. Collis's notes on the Spencer papers makes for fascinating reading, particularly his observations that 'Their defects are glaring. The spelling is poor, the grammar incorrect, the constructions involved. They contain many contradictions, false judgments, unfounded reproaches, weak deductions, examples of temper and self-deception, woolly argument and repetitions…. They are inordinately long, unreadable to such a degree that those whom he invited to read parts of them seem as a rule to have abandoned the attempt.' (pp.14–15) Collis concludes that, although Spencer was 'something of an enigma… [Y]et I dare assert that among the thousand British artists of today none is more likely to convince posterity of his genius than he.' (p.16)

2 Adrian Glew (ed.) *Stanley Spencer: letters and writings* (London: Tate Publishing, 2001) pp.12-13

3 Letter 9, 26 July 1916

4 Letter 12, summer 1916

5 Letter 8, not dated

6 From 'Mosaic', an unpublished Spencer family record, held in the Berkshire County Records Office, Reading.

7 Letter 18, November 1916

8 Letter 10, summer 1916

9 Letter 20, March 1917. A photograph exists of Stanley and Gilbert with the Bailey girls. Their father was a talented photographer who took many atmospheric images in and around the village, and also group portraits such as the very well-known photograph of three Spencer brothers in army uniform.

10 Jeremy Harvey, 'The Stanley Spencer – Daphne Spencer Correspondence', unpublished MPhil dissertation, University of the West of England, Bristol 2011.

11 John Rothenstein (ed.) *Stanley Spencer, the man: correspondence and reminiscences* (London: Paul Elek, 1979) p. 96.

12 Elizabeth Rothenstein, *Stanley Spencer* (Oxford and London, Phaidon Press, 1945) p.13.

14 Letter 8, not dated

15 Letter 22, 25 May 1918

16 The full title of the larger canvas is: *Travoys Arriving with Wounded at a Dressing-Station at Smol, Macedonia, September 1916*, oil on canvas, 183 x 218.5 cms. IWM: ART 2268. The Imperial War Museum catalogue has an accompanying text: 'About the middle of September, 1916, the 22nd Division made an attack on Machine Gun Hill on the Doirian-Vardar Sector and held it for a few nights. During this period the wounded passed through the dressing-stations in a constant stream, by means of the mountain ambulance transport shown in the picture.'

17 Letter 25, October 1918

18 I am grateful here for the reflections of Ann Danks at the Stanley Spencer Gallery, Cookham, whose thoughts on the painter and his work have been most helpful.

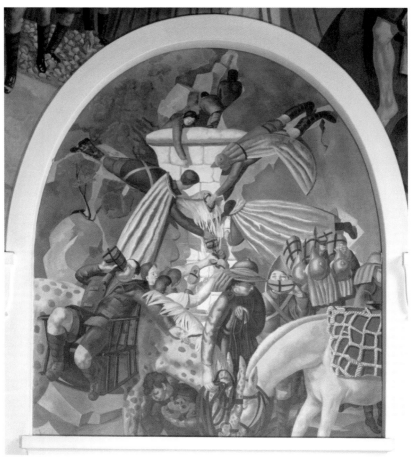

Stanley Spencer *Filling water bottles*. Sandham Memorial Chapel, Hampshire, (National Trust). Photograph ©NTPL

THE LETTERS

Letter 1

SS to Desmond sent from:
No. 100, 066, Pte Stanley Spencer
7th Company RAMC Military Hospital
Devonport
Envelope postmarked May 12 1916
One side of text only

Dear Desmond,

This is my address till, as far as I know, Monday when I believe we go on to Aldershot. I have brought my Shakespeare with me. The journey was wonderful. The clouds projected downwards below the hills. The trees were extraordinary. I did not realize I was looking out across the sea till I saw a ship up in the clouds & came to the sensible conclusion that the sea was under it.

Love from Stanley

Remember me to your Mother & Aunt, & to all the rest of your friends, who I will try & write to in time.

Letter 2

SS to Desmond from:
No. 100, 066,
Pte Stanley Spencer
7th Coy RAMC Military Hospital
Devonport
Postmark May 12 1916
Six sides of text, drawings of clouds, and a tree (side 1); cliffs (side 2); soldiers in sleeping bags (side 3); column on the march (side 4); palm tree (side 5)

Dear Desmond

We left the hospital yesterday Friday morning. I swept the ward out yesterday morning with George Saunders. I felt a bit sad, poor old George was so upset. The journey was wonderful, the clouds were particularly beautiful. You remember what I told you on the card.

This is something like what I meant. [small drawing in pencil] Drinkwater said that he used to work on some very high hills & that the clouds used to touch the hills where he was at work. Just imagine what a feeling it gives you when you think of a man working on the earth just at the place where it touches the sky. There were some trees I saw something like this. [small drawing in pencil] Nothing like it.

It was an extraordinary sight to suddenly see the sea. I have only seen it once before in my life & that was only for a few minutes. You remember the book next after the Cyclops book; well, we came to a part where the rock projected into the sea & in front of it another piece of rock something like this [small drawing in pencil]

May 16 1916. Between the space of time between this line and the one above I have been from Devonport to here, Aldershot, & my address is now as follows:

No.100, 066 Pte Stanley Spencer
No.3 Hut. D Lines
"W" Coy RAMC
Twezledown Camp
Near Farnham
Surrey

It was a relief to me to come here, you can't imagine how the loathsome tidy patched-up Plymouth & in fact all the western part of England that I have seen have this plastered-round 'finished' feeling, & to come back to Mellow old England with red brick building & red earth & green fields (not brown).

When we got to Fleet we got out & had to walk with full kit (kit bag & all) for nearly 3 miles along a straight road. We were just pouring with perspiration but it was great fun after ward work. Tomorrow we go on a rout march so I understand. There is no hospital work here. Its field Ambulance work & I think we are for that. I saw one go out today. It was a wonderful sight. Wagon after wagon & the thick-necked horses.

Later. Lights out just sounded. Here we are, rows, 2 long rows of us in the usual hut. Just lumps on the floor like this [small drawing in pencil]

Wednesday. First thing this morning we were out on the parade ground in our shirtsleeves & slippers doing Swedish drill, after that with a roaring appetite we sat down to a big bowl of tea & some bread & butter & bacon & tomatoes. Very good. After breakfast cleaned up for parade at 8:30, paraded & then were told off to several large wagons which we began to shove & hawl along. It was perfect. I felt as if my soul would bust for joy. It is extraordinary how these experiences quicken my whole being.

Yesterday we went for a 10-mile route march. A whole company ("W" Coy) in one confounded lump moving. In front one man (captain like those Egg laying insects with a little head & a tremendous body. Something like this [small drawing in blue pencil] Over sandy bumpy ground & then gorse & fir trees. It all seemed so just right. I was just ready to receive all this. At length we got to the road again [small drawing in blue pencil] over a little hillock & down into the road arcaded with beech trees making the sunlight green, because the light we got was coming through the leaves. We were to have worn packs yesterday but they thought it was too hot for such untrained men. Afterwards our section were told that we did well. We had a lot of compliments from the officers greatly exaggerated by our very excellent sergeant. He is so naturally virile & keen, intent, & yet extraordinary expansive. His boyish energy intelligence & interest is beautiful. We are going through very strict training. Practically all my hair is off. Clipped right close like a criminal, in fact I feel like a rejoicing criminal.

Last night I had a bathe down in the canal which is quite beautiful. Where we bathed was a little enclosed space on the bank. Almost in the centre was a palm tree in bloom & by its side a man drying himself. [small drawing in blue pencil] This morning we had a grand parade & were inspected by our commandant. 2 whole companys on the parade ground, "V" Coy & "W" Coy, & all dressed in full marching order. It's lovely the way the sergeant's talk. On the heels, <u>rise</u>, on the knees, <u>bend</u>, & all said so horribly mechanically, but this Swedish drill is not bad for you, in fact it is good for you but it is ridiculus. Can you imagine what it is to me after going to the wards in the early winter morning when all is dark & close & stuffy & lazy, & then getting up the same early hour & going out into the

country lanes with just slippers & trousers & shirt on & going for a nice walk, & then a double & then this drilling which is very stiff & that shows it is rong. We are always in the open & that is just what I longed for. I got your 2 letters you sent to Devonport when I was there. The first part of this letter was written there. When we were pushing great wagons along the other day I thought of the Odyssey. What a glory there is in doing! It will be a great stimulus to me when I get back to painting. Write to me at this address

No.100, 066 Pte Stanley Spencer
No.3 Hut. D Lines
"W" Coy
Twezledown Camp
Near Farnham
Surrey

I am afraid that some of your letters have gone to Devonport & have not been forwarded. That is my fault.

Yours always
Stanley

When on our route march we were marching under the beeches, their shadows simply poured down the soldier's backs. The sun was right overhead.

Letter 3

SS to Desmond written from:
No. 100, 066,
Pte Stanley Spencer
Hut 3. D Lines "W" Coy. RAMC
Tweseldown Camp Nr. Farnham Surrey
Received May 25 1916
Three sides, three small drawings of gardening activity (side 3)

Dear Desmond,

I got the page out of the letter you sent to Devonport. It was forwarded to me from there. It is grand to take your translation out of my haversack & read it during the intervals of drill. Tomorrow is

another long route march with full packs. That will mean some more reading under the tall pines. The fact that there is a definite time given in these rests by the roadside enables me to read, whereas when I sometimes had ½ hour to hang about at the hospital, I could not grasp what I read. You always had a feeling that someone would pounce on you for something to do. I feel I would like to draw the land & trees & tents here but I doubt if I should be allowed to, but I shall see about it. The camps & tents make me want to do a big fresco painting. This afternoon we had racing on the greens.

It was grand. We just go out in our slippers, trousers & open shirt, & we run just as swiftly as we can. Running in time along with a hundred men is fine. I am reading again Macbeth. I want to go over again all the plays I have read before because it is very important to do so.

In that little book of English poems you gave me, is some Milton. But I cannot keep away from the thought of the Odysseus thing. It is a part of my day part of the 'doing' and part of the day. I also have a little book of Giotto & the book of the church of St Francis of Assisi, both books I carry in my pocket or haversack according to the dress, so that even Giotto is dragged into this drill. I will close this now with love from Stanley.

It seems quite funny to think of you being out. I like you to write out some Beethoven that I know as you have done. The Gluck would be useless for me to try to read unless I knew it, & I am nearly sure might with a struggle be able to remember some of those things you mentioned out of Gluck that you have played to me.

Yesterday I went gardening in the afternoon, well, I had to go into a gravel pit & dig several barrowful of good manoeuvring soil (lovely colour) & take it to the garden on the other side of road. This without exaggeration [small drawing in ink] is the nature of the track I had to wheel a big barrow of soil to the garden. Not only was it hilly but it had the most distracting twists & the track was sometimes like this & immediately after like this [small drawing in ink] so that the only thing to do was to trust to faith & simply charge. If you did not go as hard as you could, the barrow would get stuck at the bottom of a steep place & there you were. These lines [small drawing in ink] give you some idea of the angle of the wheel of the barrow.

Letter 4

SS to Desmond written from:
No. 100, 066, Pte Stanley Spencer
Hut 3, D Lines "W" Coy. RAMC
Tweseldown Camp
Nr Farnham Surrey
Received June 10 1916
Six sides of text, drawing of Fernlea garden in plan (side 4),
drawing of a marching band (side 5)

Dear Desmond,

I went home on Saturday for a day & a half, I had been quietly long-
ing to see my brother Sydney, & I went home & opened the door &
there was Sydney. We embraced one another while my par stood
wondering when my brother would introduce me to him. My hair
being cropped close like a convicts, my daddy did not know me. As
all the men are having an after dinner sleep & the hut door will open
& a voice which frightens will cry "fall in", I will stop. I hear the
sergeant's cane on the neighbouring hut doors.

This afternoon we have had hell. There are a few dull & a few don't
cares in our company & that means we shall go on doing squad drill
for the rest of our lives. You march along & in right wheeling one
man does not keep his dressing, that section of 4 is taken out & put
into the backward squad. They make a slip there & they are in for
fatigues & C. B. [confined to barracks] The Captain commenced
training us in this manner, "Oh, I see some of you don't want any
dinner. I can see we shall have to stop your weekend passes. If you
were at your depot you'd be doing C.B. all the day."

Next day.
This morning we have been doing right & left inclining. Awful.
I think that the translation you have just sent is not quite as fine as
the Achilles one, but I think that is partly due to the original Greek.

Later.
Now the day is over I feel I can breath more freely. This afternoon
there was a great thunderstorm. One flash made us flinch as we
marked time under some trees just off the parade ground. Some of

the men forgot they were marking time, & halted. When we got to the parade ground we noticed a man walking off with a dirty khaki hat in his hand with the hatband broken & the badge all burnt, & we afterwards learnt that a Lance-Corpl of "V" company had been struck dead under the tree just on the other side of our parade ground. It struck the tree which has a lot of nails in it & down the side of the man's face & his toes. I believe it is route march tomorrow. I hope it is. I accidentally left my Canterbury tale book at the Beaufort Hospital but George Saunders sent it on to me, & it is just the thing to read here. Especially the very beginning of the book. When I was home I went to see some girls that live opposite us. Out of their window you see the signboard of the King's Arms Hotel, a very old place, & further up to the right one of my precious cowls appearing over the cottage.

And then these girls. I felt I could hardly dare think that all this really was. It was all somehow withheld from me. All my earliest compositions were influenced in a certain way by these girls. They belong so essentially to Cookham. It made me ache to go down to the bottom of our garden & look over the low wall across to the back lane school.

[pen-and-ink map of this: in the garden; many trees particularized, e.g. 'Williampear tree', 'laburnum tree', 'apple tree (giant apples)', 'cherry tree', 'fir tree', 'rose trees']

This morning we went on another wonderful route march. This time we went through Farnham which is a broad streeted town with a very heroic 'Knights of old' atmosphere, at least it had for me this morning as we entered it going down hill; that going down hill & the broadness of the street & the tall old buildings had a lot to do with this feeling, & the stick in the air like this [small pen-and-ink drawing], you cannot calculate where the arm comes from or to whom it belongs, but it keeps shooting up, & then the other. It is awful to feel your pack gradually getting at you, but the land is a great boon & relief.

I am just going to write to a man named Wood. I want him to come & see you, if you don't mind. His military life is getting on his nerves & in fact he has had little chance at any time of doing anything he would have done. He has just sent me a book of

and then these girls. I felt I could
hardly dare think that all this really
was. It was all some how withheld
from me. All my earliest compositions
were influenced in a certain way
by these girls. They belong so
essentially to Cookham.
It made me ache to go down to
the bottom of our garden & look over the
low wall across to the back lane
school.

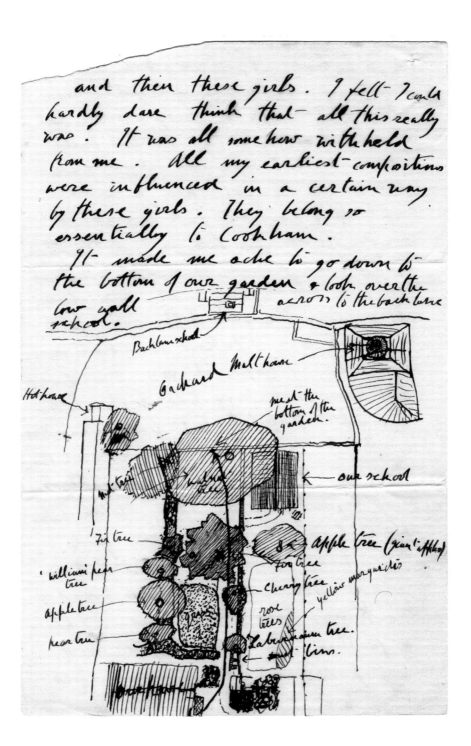

Back lane school

Orchard Malthouse

Hot-house

near the
bottom of the
garden.

← our school

fir tree

william pear
tree

apple tree

pear tree

apple tree (gran't Attha)

fir tree

cherry tree yellow marguerites

rose
trees

Laburnum tree.
lilac.

Donatello & the other day he sent me a book of the life of Gaudier Bresyska which you mentioned having seen in George's. I hated Gaudier when I knew him, but I agree with you that he is extraordinarily certain & true in his drawing.

Love from Stanley

Letter 5

SS to Desmond written from:
No. 100,066. Pte Stanley Spencer Hut 3.
D Lines "W" Coy. RAMC
Tweseldown Camp
Nr Farnham, Surrey
Received June 19 1916
Four sides of text, three drawings of trees and hedges (side 2); drawing of soldiers in training (side 4)

Dear Desmond

I hope you will be able to keep up your standard of letters to me, even if I do not keep writing to you. I should like a photo of you. Now that I am here I look back on the time I spent with you & it appears so beautiful to me. It clears my head, which gets muddled at times. I get muddled because I keep straining after something & that something ends up with a desire to paint or draw something and then I feel how impossible it is & then I don't know what to do. I shall be glad when we get to the manoeuvres which are more interesting, especially when there are night ones, & one has to go out & search for wounded which are previously distributed over the country.

I do not expect we shall go out for a year perhaps. The thing we have to do now is latrine building, which is not bad. This morning was the memorial service for Lord Kitchener. There were over a thousand men on the parade ground. [Here a pen-and-ink drawing, followed by two others on the same page] The above drawing is this: [here the second drawing] only I could not quite explain that shape. Just at the juncture of the two hedges is a tree with shining leaves & they glittered in the sunlight. This below is rot, it is nothing like what I meant to show. I was trying to show you a row of

may trees just at the back of Crondall Village. They all go one way, & the clumps of foliage are more separated, like this. [Here the third drawing] But the thing at the top of the page did move me. There was something that was so definitely full of sacred meaning to me. The little book of Duccio (which goes nicely into my pocket) is feeding me. I have looked through it once. To look through a book for the first time is a very exciting performance for me. I always like to wonder what a picture is going to be like before I look at it.

On our route march today we got off the road & on to a wide track which got narrow & muddy & we had to scramble through the bushes surrounding us. Over a thousand men in single file going through this narrow space & round corners, where they disappeared, though you could still hear them talking.

I must get my pack ready for tomorrow's general inspection by the Commandant. He sees everything, he has eyes all over his head.

The general inspection is over & we have come off well, I mean our section – section 4 – of "W" Coy. The Commandant was full of praises as he walked down the ranks. I have heard that the Commandant said our section was the best section of the whole lot. He was particularly pleased with our packs. I have also heard that as a result of our 'soldierly' & 'intelligent' appearance we shall be on the next draft. This morning our Section Commander 'put us through it' for some reason. We got up expecting our mild double, but when we saw the Section Com: we knew we were in for some fun. The Sec: Com: just made a beeline for a certain place, & no matter what was in the way, made straight on. We just carved our way along. We went up on to some land which [is] in a state of upheaval owing to the trenches there. When we got there we had to run round & round in a huge circle & keep leaping these trenches. Then we had racing, & then we doubled back. [Here drawing in ink of men running round and round]

Yet another day, & I feel as different a person as if yesterday had been a year ago. I am going to do a composition, I believe. Somehow I feel I can here. The photo you have sent me today is grand. Are there many of these corbels? I have been having another look at the angels in Giotto's Martyrdom of St Paul.

With love from Stanley

Letter 6

SS to Desmond written from:
No. 100066 Pte Stanley Spencer
Hut 3 D Lines "W" Coy, RAMC
Tweseldown Camp
Nr Farnham, Surrey
No date marked on letter, assumed Summer 1916
Two sides of text, drawing of sleeping soldiers (side 1); three drawings of soldiers asleep (side 2).

Dear Desmond,

I quite forgot & went & put your Bristol address on my letter to you. Did I tell you that I had a book of Donatello sent me, & it is extraordinary, there is a reproduction of Ghiberti's creation in his doorway in the Baptistery. This particular Ghiberti has been my food for years. The men are sleeping this afternoon like this. One man had his head in a wonderful position. [Two small drawings]

Later.

Another man slept with his hand mysteriously appearing behind his head. [Two more drawings.] It is so wonderful to see all these things in actual life. I have just got the book of Duccio di Buoninsegna.

Letter 7

SS to Desmond written from:
No.100066. Pte Stanley Spencer
Hut 3. D Lines. W Coy RAMC
Tweseldown Camp,
Nr Farnham, Surrey
Received July 24 1916
Three sides of text, drawing of a soldier asleep (side 1); drawings of gas masks (side 2); drawing of Swedish Drill (side 3).

Dear Desmond,

This evening I have been rereading a lot of your old letters & I find that accidentally among the ones I have left at home I have left the

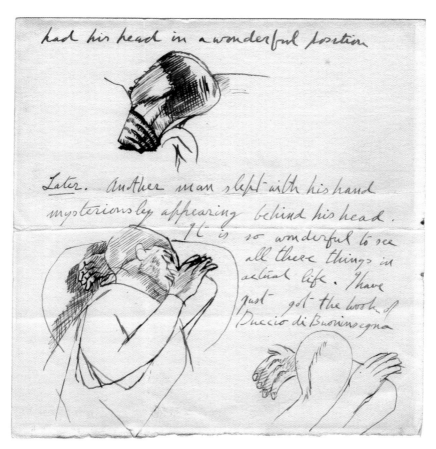

one that had the wonderful quotations out of the confessions of St Augustine. "God worketh & his work is God". Can you provision me with some more of St John of the Cross? Do you ever hear from Mrs. Daniell? [Here pencil drawing, probably of someone in the hut, with the note 'Isn't it rather fine the way this man lays down'] I should like to hear from her. I should also like to hear from Mr. Press.

Tomorrow we begin our course of special drill: Water cart drill sounds fine yes, there is something excellent about that. Just setting out in search for water & then purifying it & bringing it back to the camp.

We have been walking about with gas helmets on all the morning & they give you a sick headache, the smell is so sickly. We look most bonny with them on. [here three pencilled faces in helmets] But truly aren't they devilish? They horrify me.

This afternoon we have had them on again. This morning we had a lecture by the 'staff' (sergeant) which had it been delivered to men in trenches it would have saved their lives. For instance in some cases the men have ripped off their gas helmets because the smell of the hat became stronger & they have thought the gas was getting inside. Of course they have died. The gas affects the stuff the hat is dipped in so as to cause it to smell twice as strong. He impressed

upon us the fact that the gas came sometimes white sometimes black, he said they can use colourings in the gas. He told us & proved to us the futility of liquid fire. The jet of flame goes at the furthest 30 yards. It has to be sent off at such an angle as to cause it to be almost exhausted by the time it reaches the trench. It cannot last much over a minute. If you get into one of those little firing places & the direction of the fire is this [pencilled diagram], you are as safe as if you were on the inside of a waterfall. Very obvious but how essential to the dull of understanding.

Today is the only day in the week I like. It is route march day. And this afternoon we just did Swedish drill & lots of foolish rather risky drills such as bending back stretched across a form like this. [small drawing in ink]

I got your letter this morning & the ballad "The Frigate" was great, though I felt I wanted to sing something to it all the time. I wish I could read other things such as the other quotations in the letter with the same amount of freedom. I have to tax myself very hard to read those other bits in your letter. But I got well away with "The Frigate". Your photo greatly pleased me. You can't expect me to understand mass or to feel all that mass would make you feel, so if you can you might expound. I shall be glad when I can get back to raising altars. I must get on with my kit.

With much love from Stanley

Letter 8

Letter not dated nor with named recipient, assumed to be Desmond. Two sides of text.
No illustrations, text written horizontally and vertically on side 2.

Thank you for that beautiful letter. It is impossible to concentrate down here because there is a continual noise. The man who sleeps next to me has a noisy brain, if you know what that is like. I do not get one minute's quiet since I have been here except when I have been home. There are thirty men present when I write these letters to you. Today it has been gas helmets again & disinfection. When I was at hospital the work was actual. Here it is trivial. There is no

binding the spirit. Jeoffery Keynes a young doctor I knew was saying that he had got to go on duty for 2 years without a stop. That is how human beings ought. That we may obtain everlasting life. This is how I am always wrong. Sometimes I feel alive but only sometimes. There is something so unstead fast about that.

Later. This morning we were on the watercart down at the Basingstoke Canal. I should just love that job. It is so fine. The horses have thick fat necks & short ears set back. As they lurch forward to pull the heavy watercart their glossy skin wrinkles upon their backs & buttocks. They have wonderful bow noses. This afternoon we went 'doubling' with gas helmets in the blazing hot sun. How lovely it is to get a wash afterwards; they are so greasy these helmets & are composed of 2 layers of thick flannelette, greasy & dirty & we breath & suck through a rusty bin tube covered with a piece of transparent India rubbery stuff which you grip with your teeth (you wonder who gripped it last). You must not breath through the nose.

It is awful the way the Sergt. Section Commander threatens his men. He has a proper red hot Irish temper & when he looses it he walks slowly towards the offender swishing his cane up & down in front of him. Just before he stops before offender he brings his cane up with a sweep over his shoulder & stands in the position of a man about to strike someone.

What is so exciting to me is the thought of the water we are pumping into tank has got to go through 2 close wire netting circles smeared with Alum. All this goes on in a cylinder round the inner cylinder which is perforated all over is wrapped a very closely sewn sheet of canvass, wrapped so many times round that it makes the water pass through three layers of canvas instead of one. It passes through 2 sheets of Alum as said but in getting through it is checked by blind end of inner cylinder but there is a small space between inner & outer cylinder & water has to go there. At end of inner cylinder is a hole & pipe leading to Tank which holds 80 gallons. When we begin pumping we have to wait a long time before we hear the water trickling into the tank. During the silence we know a great struggle is going on inside. The water begins to trickle out of a crack here or a screw there. Then there is the next thing to do, we have to test the water & purify it, which is so beautiful.

I do not remember what it is we remove from the water but it is great fun doing it. We have 6 cups, nice clean ones, set in a row & filled with water from tank to within ½ inch of top. 3 drops of testing solution is put in each pot. We have a black pot & a tin full of bleaching powder & a 2 dram measure. We fill black pot up to mark with water & put one little measure full of bleaching powder into it & mix it into a thin paste. We then put 1 drop in first pot, 2 drops in second & so on to the sixth. Then the pots are left for ½ hour. We return when time is up & notice that Nos 1 2 3 4 & 5 are no longer blue & No 6 is not as blue as it was. In this case we should have to empty pots & put drop 7 8 9 10 11 12 respectively into each pot. No 7 would be the one & we should put 7 measures of Chloride of Lime into it, mix it up & pour it into tank. And behold you have pure water. The Alum causes a cloud to be formed inside a partition into which the water flows & all impurities in solution are separated there. The canvas collects all impurities in suspension. The Chloride of Lime destroys all bacteria.

I want to finish "Crime & Punishment"; could you get me one? I could read a good 'novel' like that down here. I find the jump from some foolish duties I have to perform, or some rows I have, to the poets is too great. I can't concentrate. I associate the poetry with the unpleasantness. But a book would aid me first by exciting my idle curiosity, then by real & great curiosity & then I get inspired & then I want to read Shakespeare. I know in theory this is not right but under these circumstances you would realize how difficult it is. Surrey is jammy & sticky like a tin of golden syrup but that is how Surrey makes me feel. There is something definite, clear & concluded about Clifton & thereabouts, but it is just morbid & to me the essence of Melancholy, a kind I used to enjoy. You see Desmond I feel so disturbed unsettled & sometimes desperate about what I am going to do. If I was in a place where I had got to stay for duration of war I might be able to collect myself, but when you are told you with be away in 10 days you can't settle down at all. But I know what you mean, that a man can 'live' in perfect felicity under any circumstances & [not?] remain unsatisfied & of course that is true but I can't do it yet.

With love from Stanley

Letter 9

SS to Desmond written from:
Pte Stanley Spencer, No. 100,066.
Hut 3. D Lines "W" Coy. Tweseldown Camp.
Nr Farnham, Surrey
Shewring transcription states: July 26 1916
Three sides of text.
Side one of letter reads 'Summer 1916'.

Dear Desmond

Even though you seem to be in the same impossible condition as I am, yet your letter was very fine. The annoying thing is that I am not in this condition really, only superficially. Today I have soaked through 2 shirts. This morning was a route march too hot to be anything to me, except at moments. It rather gave me contemplative feelings when passing under some trees with spare foliage we heard, gradually becoming more decisive above the din of our band, a church bell ringing, & the church is on us before we think we are within 20 yards of it. I was not contemplating on anything, I was just contemplative.

I have never seen that out of paradise lost. I have only read a little bit, but God, isn't that wonderful, incisive? And isn't it lovely to think of him, Milton. I always feel very peaceful when I read him or think of him. I when I hear Bach desire nothing better, but I still crave to create.

The news is very bucking tonight. The capture of Pozie'res seems to be a great advantage, yet another step on the road to Bapaume. I was watching the sun helmets coming in & the lovely cool 'drill' suits coming in for the 100 men going out of our coy, this week & thinking of the fact that their dull training had come to an end. They are going to Salonica. I have heard that 200 are wanted for Mesopotamia. I hope some of us will be picked out.

The great arguments that go on in this hut are between trades, & some are great fun. There are 2 fine firey youths out of a cotton factory in Bolton, spinners they are. There is also a very 'shopy' ginger headed man who has come from behind the counter in a co-op stores in district of said Factory. There are a lot of coalminers

in this hut.

My friend in this room is a man who is cross eyed, gets drunk & always puts an 'I did' on to the end of any of his achievements. He comes from Middlesboro' he does, & there isn't a better place in the world there isn't. He is a carpenter & joiner on one of those big Monitors in Middlesboro docks, he is. He always talks in a low grumbley voice. I love the way he used to live. He used to earn sometimes £4 a week, piece work. He used to give £2 to his mother, the rest he saved to the amount of about £20 pounds & then he spent all that in about a week. But his knowledge of carpentry – you think of mallets & chisels when you look at his face.

If he gave you anything he would not know that he had given you anything ten minutes after. And perhaps you have noticed that in these 'disgraceful characters' is the true power of forgiveness. He went home for his 6 days & when he came back he was assisted into the hut by his mate. I woke up to hear this in a resigned apologetic voice, "I've come back I have". The next morning he produced a long stick of 'Middlesborough Rock' and then he put his hand into his pocket and slowly drew out 2 new clay pipes, but before he took them right out he looked doubtfully into the pocket, then a smile came into his face and he handed the pipes to his mates. 'Its alright I thought they were dead, I did'. I will write again later on, and God bless the Middlesboro rock.

From your loving Stanley

Letter 10

SS to Desmond written from:
No. 100,066 Pte Stanley Spencer
Hut 3. D Lines "W" Coy.
Tweseldown Camp
Nr Farnham, Surrey
Letter dated 'Summer 1916'
Two sides of text

The enclosed dirty sheet is the beginning of a letter but I could not go on with it. J Wood is in London for a week or so. I have given you his Trowbridge address at the end of this letter.

Dear Desmond,

I have received goodness knows how many postcards from you since I wrote to you last but I cannot help it. And I have not been in the condition to enjoy such beautiful things as I would wish. I am not brazen faced and I shall never be able to stand the bullying of these sergeants. At least I shall stand it but it will always hurt me, always shock me. It is useless to say to myself 'ok they are ignorant etc'. Do you know what it is to be watched all day persistently by a sergeant who is trying to crime you. I can't write letters and enjoy anything much while this kind of thing goes on. I have stood in their hut & asked them to crime me but the section Commander will not. He is rather fine in some ways but there is something dreadful about him. When he closes his eyes you can't see where they are closed because his eyelashes are the same tone as the flesh.

I will think it over about coming to see you (we are having divisional leave 6 days) but I must & will see Jacques Raverat who I have told you about. He is helpless in both legs & goes about in a wheeled chair. They, he & his wife, were very curious to know about you & I told them. I do not know how it is but though they hardly ever write & have not done anything particular for me, yet to go without seeing them gives me real pain. I have not seen them for over a year. Although I feel so vacuous for writing I feel rather pleased with a composition I am doing of the Flight into Egypt. James Wood's address is R G A, Cadet School, Trowbridge, Wilts. He was very disappointed not to see you. This is just to let you know I have received your cards & letter.

Love from Stanley

Letter 11

SS to Desmond written from:
No. 100,066 Pte Stanley Spencer
Hut 3. D Lines "W" Coy.
Tweseldown Camp
Nr Farnham, Surrey
Letter dated 'Summer 1916'
Two sides of text

I am on the R C parade on Sunday & I want a book of the order of Mass. I have found it impossible to go to these C of E parades.

Dear Desmond,

I am receiving one corbel per day from you. I agree with you that the one you said was the best is the best. The way the leaves go at the top of it.

The same sort of work is going on here. Insolent sergeants with good permanent posts. They are not in a hurry for us to go away. I have not read shelly except the Spirit of Solitude & I also read nearly all of the Revolt of Islam but could not follow it at all. "The Spirit of Solitude" was wonderful to me. I remember reading it in our dining room at home one afternoon & I remember what a lovely feeling came over me. The lines that you quote I do not like a bit. I think that it is just a scientifically "thought out" thing that any man with an academic knowledge of the language could compose. It is not inspired.

I have been looking at the Old Testament lately & at some of the parts I used to like reading most. I used to love nearly all the books. Samuel. Do you remember, I think it is in the 1st or second book of Samuel, how God speaks to David & says, "And it shall be that when thou hearest a sound of going in the Mulberry tree then shalt thou know that I am with thee..." I cannot find the place where this passage is but I think these are the words. They are nearly correct.

Love from Stanley

Letter 12

SS to Desmond written from:
Pte Stanley Spencer
Hut 3 D Lines "W" Coy,
RAMC Tweseldown Camp
Nr Farnham, Surrey
Letter dated 'Summer 1916'
Two sides of text, drawing of surgical operation (side one); and two drawings of stretcher-bearers in a trench, and a patient in a trench bay (both side two).

Dear Desmond

I have just been home & when I got back I found the Ord of Mass waiting for me. I am looking back on 'Beaufort' days & now that I am away from the worry of it I must do some pictures of it – frescos. I should love to do a fresco of an operation I told you about. And have the incision in the belly in the middle of the picture & all the forceps radiating from it like this. [small pencil drawing] It is wonderful how mysterious the hands look, wonderfully intense. There was something very classical about the whole operation. Major Morton looked away from the incision when he was searching & feeling in it. What is so wonderful also is the stillness in the theatre & outside the swift silent steps of those "fetching & carrying". I would like to do a figure on either side of picture of operation of a nurse & a man with frock bringing sterilisers. This does not sound much but leave it to me.

We are still training. We go into the trenches & bring the wounded out. We have to keep our heads down because the captain tells off a party to pelt us with stones if we show ourselves. I love to watch long rows of men in front of me in trenches.

The trenches are so solid & sometimes the communication trenches are so narrow that the gassed man we are carrying in his overcoat gets wedged, & it gives me such an extraordinary feeling. [drawing here] when we came out this morning we were caked in clay. Then those ledges you know let into the side of the communication trench. We put our patient there for a rest & it looked fine. [drawing]

I believe we are going to the East. I have heard that it will be for Mesopotamia but that is all just what I hear. As a matter of fact I think that we shall never go at all. It is dispiriting, there are men here who just do the dull work in a sort of hand dog manner & the C O sees it & that puts us further away from the time when we leave - & what if we do leave, we shall be sent as Nursing orderlies to some damned hospital in Bombay or some other vile place.

We are still training. We go into the trenches & bring the wounded out: We have to keep our heads down because the captain tells off a party to pelt us with stones if we show ourselves. I love to watch long rows of men in front of me in trenches. And the trenches are so solid & sometimes the communication trenches are so narrow that the ~~wounded~~ gassed man we are carrying in his overcoat gets wedged & it gives me such an extraordinary feeling. When we came out this morning we were caked in clay. Then there ledges you know let into the side of the communication trench. We put our patient there for a rest & it toned fine.

I believe we are going to the East. I have heard that it will be for Mesopotamia but that is all just what I hear. As a matter of fact I think that we shall never go at all. It is desperating, there are men here who just do the dull work in

95

Letter 13

SS to Desmond written from:
Pte S. Spencer Hut 3 C Lines
"W" Coy Tweseldown Camp
Nr Farnham, Surrey
Letter dated 'August 1916'
Two sides of text

Dear Desmond

I have not been able to write lately as I have been very busy preparing to depart for the East somewhere. I am now ready, even down to having made out my will which I did this morning. Budden & Drinkwater also did theirs. We were given forms on parade & found them to be wills!

Of course we shall be in hospitals but I shall stick it alright, though I wish it had been a Field Ambulance. I went home for 4 days leave & saw no one except Pa & Ma & sister, & Henry Lamb came down to Cookham to see me on the day of my departure. I have been reading St Johns Gospel a lot lately & it is great. I think it is the greatest. This verse, & many other like ones, is so plain & beautiful. "And he brought him to Jesus. And when Jesus beheld him he said, thou art Simon the son of Jona; thou shalt be called Cephas." It is so much the way I always imagined Christ to speak. How it sets my mind in order. I have sent my large vol. of Shakespeare home. Impossible to carry such a book. Much better have a play sent as desired.

I am able to take Canterbury Tales as it is more packable. Also the little blue book you sent me, & some Gowans & Greys art books & if possible "Crime & Punishment". In any case if we are in hospital it will be better than wasting time here. Your letters do seem such a contrast to this life. This morning was a grand parade in our khaki 'drill' & sun helmets. It looked fine.

Yours always

Stanley

I will let you know as soon as I can of our next move & new address.

The Letters

Letter 14

SS to Desmond written from:
No 100066 Pte Stanley Spencer
Hut 3 C Lines "W" Coy
Tweseldown Camp
Nr Farnham, Surrey
Received August 23 1916
Single side of text

Dear Desmond

We are going early tomorrow morning for the Far East. Reveille goes at 2.30, breakfast at 3 or thereabouts. Rather dramatic isn't it? I will let you know my further address as soon as possible.

I have been reading St Johns Gospel, isn't he wonderful. I have not realized him so much or so clearly as I have these last few days.

We sleep on the baseboards tonight as everything has gone back to the stores except the blankets. I have all the books I wanted except Shakespeare which would have been unpackable, you see the others I was able to 'pad' my kit with.

I think what you said about the Liturgy & Tradition was saying all that was necessary to make things clear.

Love from Stanley

Letter 15

SS to Desmond written in 'August 1916 on ship'
Four sides in total; side 1 text and two small drawings of sailing ships; side 2 has two line drawings of sailing ships; side 3 has text and a small drawing of coastal hills, and side 4 has outline drawings of figures and large circle (possibly a porthole).

Dear Desmond

I am looking at Africa, the Moroccan coast, & smoke is rising from behind one of the peaks. I have got my Odyssey that you wrote out & I am thinking about Cyclops. I do wish you were with me. It is nice to have Budden. I really did not think it was going to be so just

97

Aug. 1916 on ship

Dear Desmond.

I am looking at Africa, the Morrocian coast. & smoak is rising from behind one of the peaks. I have got my Odyssey that you wrote out & I am thinking about Cyclops. I do wish you were with me. It is nice to have Budden. I really did not think it was going to be so just what I wanted It is like discovering yourself. I want to post this at Gibralta. It makes me tremble down in my inside every time I look at yonder coast. We are just opposite a huge rock which is just the colour of pummice stone & feels like pummice stone. Later. We have passed the cape of Gibralta & Africa is almost out of sight. On the African side is a big sailing ship full of sails, absolutely shakespearean.

I am thinking of The Jew of Malta & him looking down at warships coming into the harbour.

D) Drawing on back

This is getting round this way now.

23

what I wanted. It is like discovering yourself. I want to post this at Gibraltar. It makes me tremble down in my inside every time I look at yonder coast. We are just opposite a huge African rock which is just the colour of pummie stone & feels like pummie stone.

Later. We have passed the cape of Gibraltar & Africa is almost out of sight. On the African side is a big sailingship full of sails, absolutely Shakespearean.

[two small drawings of ship here, the second inscribed 'she is getting ground this way now.' Two more drawings overleaf]

I am thinking of the Jew of Malta & him looking down at his ships coming into the harbour.

I think we must be off the coast of Tunis as this is the nearest we have been to the coast of Africa.

It is not mountains now, but great rolling sandy hills that of course go up to a great height. Each hill is peculiarly rounded & dome like & gives a slight hint of what Egypt is like. It is dotted all over with white buildings that look like palaces or Mosques. If we go to Malta we shall not I think be able to see Tripoli as it will be too far south. Out to the left the hills rise to a great peak on top of which is one of these large white buildings, & the sun which is nearly set is shining full upon it. These hills are peculiarly wrinkled like the wrinkles on the back of a bullock's neck, most wonderful.

[small drawing]

A canary has been bobbing up and down along side of us for some distance. They fly in much the same way as a Fieldfare.

Letter 16

SS to Desmond, written from Salonika
Letter dated 'Autumn 1916';
Two sides of text

Dear Desmond

I have just got your letter which was written the day I left England. A helpless, suspended feeling seized me as I suddenly noticed the side of the dock we were in, begin to slide away from us. It was a

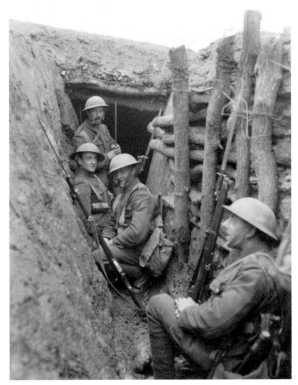

Life in a Salonika trench. [Imperial War Museum]

wonderful voyage, but I will describe it when we return. My address is 68th Fields Amb., Salonica Forces, Greece. I am glad to be away from the Training Centre & doing something & not in a hospital. But oh, for an English sunrise, that seems so charitable & to bring abundance in her arms!

I used to feel that my day's work & desires rested in the lap of the morning sun, & I used to love to contemplate it there, when I had my bathe, before taking it so to speak. You know, Desmond, it is awful the way I am suffering, being kept from my work like this. It will not I think do me harm but it is exasperating. I can hardly look at pictures sometimes. If you can send me any book, do, please, as I am longing to read Something. I had to leave my Shakespeare behind at home, but I took the Canterbury Tales as a substitute.

Your letter was a wonderful thing to read, especially in this barren country. Just before your letter came I was reading another, old letter

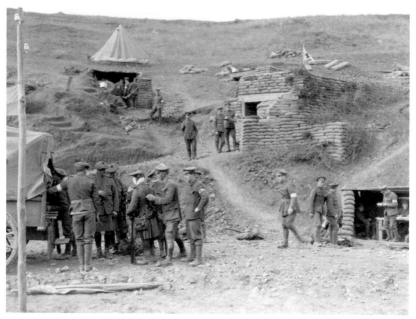

A dressing station on the Salonika Front in 1918. Walking wounded are helped into an ambulance by Royal Army Medical Corps orderlies.
[Imperial War Museum]

from you with the wonderful bit of Milton out of Paradise Lost. Description of the garden. "--- airs, venerable airs. Breathing the smell of field & grove" which words you underlined and compared them to sonata op. 28 which I cannot recollect. Write down some bars of it. I think John Ruskin, though such a bore & so absolutely wrong, is a very fine man & fine writer & says some fine things. Anyhow I enjoy reading him, & rather wish I had some of his modern painters. I had to part with dear Lionel Budden at the rest camp out here. I do not know where he went to. I wish you could send me a drawing block & some pencils. I can get nothing here. But it is a joy to hear from you, & I hope to come to this place when I return. Send me some St Augustine's confessions & St John of the cross.

I must reserve all descriptions till I get back. I am safe & well, & I think I shall keep so. I have read St John again & also the Epistle of St Paul to the Romans. There is great unity in it I think.

Letter 17

SS to Desmond, written from Salonika
Received November 1916
Two sides of text

Dear Desmond

I do not know if any letter from me has reached you, and I cannot remember if I answered your letter you sent to Tweseldown, which was forwarded to me out here. Since then I have had no letters from anyone, & this is I think the 28th October. You will have to wait till I get back to England before I can give you any news. I am still keeping well. I have no idea where Lionel Budden went. My address is: Pte S. Spencer No 100066, 68th Field Ambulance RAMC, B.M.E.F., Salonica. I still have several of your letters with me, I am determined not to 'shed' any 'feathers'. I am more than thankful that I brought some little books & things with me. I only wish I had brought my Shakespeare, though I do not think I could have managed it. Oh how I long to paint! A man told me that Malta possesses many old churches full of frescos, & one in particular called the church of St Paul, which contains the life of St Paul on its walls. When this man told me this I began to long. I could not help thinking what a glorious thing it was to be an artist; to perform miracles, & then I wanted to work & couldn't. If I see a man putting a bivouac up beautifully I want to do it myself. And when I read of Christ raising the dead, I want to raise the dead myself.

Write out little scraps of music that I know. I am starving for music. Would it be too much to write out or send me out a copy of some of those songs that Mrs. Daniell used to sing? By Jove I shall not forget those times.

I shall visit Bristol when I come home & we shall have to 'go our rounds' once more. I shall have a lot to tell you. Do send me out some little book, a good Dostoevsky that I have not read, or something by Hardy. I have not read anything by him except poems. Send me some more Milton & Shakespeare.

Please remember me to your mother.

Much love from Stanley

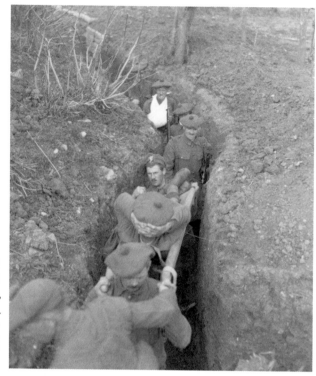

Stretcher-bearers carrying an injured man, Salonika. [Imperial War Museum]

Letter 18

SS to Desmond, written from Salonika
No 100066
Pte S. Spencer, 143rd F.A.,
Salonica, Greece
Possibly November 1916
Two sides of text

"The Mass companion, Keats, Blake, Coriolanus, Michaelangelo, Velazquez, Claude, Early Flemish Painters. Drawing book. Box of chocolate."

Dear Desmond

I was feeling rather homesick the other day so I wrote the enclosed. I do not feel like writing now but reading. All the books came today. Yesterday I came to that in Paradise Lost where Sin & Death are making the broad way from Earth to Hell:

"Death with his mace petrific, cold & dry."

I feel relieved that your operation is over. I used to love yet hate going to operations. I am going to do something about the sea. My love for home & my love for the sea seem both to stimulate my thoughts. Well, I must read, with much love to you Desmond & thanks.

Your loving friend
Stanley

No 100066 Pte S. Spencer, 143rd F.A.,
Salonica, Greece.

Please remember me to your Aunt Sybil.
I do not think I can get Gil with me.

I have to acknowledge 3 letters from you in this but I will write properly when I feel more patient.

I have a complete Shakespeare & Milton now. Isn't this wonderful, out of Proverbs? I forget if I reminded you of it in my last letter.

There be three things which are too wonderful for me
Yea four which I know not:
the way of an Eagle in the air;
the way of a serpent upon a rock;
the way of a ship in the midst of the sea;
and, the way of a man with a maid.

I think that last the way of a man with a maid, coming as it does after the other three, is most beautiful.

Letter 19

SS to Desmond, written from Salonica on paper headed 'British Red Cross and Order of St John'
Three sides of text, third side written in two columns
Dated Jan. 4 1916, but this has been corrected to read Jan. 4 1917.

Jan. 15 I am now back at the base awaiting return to unit.
Jan. 16 I am still here, remember me to your mother & to all my friends in Bristol.

Dear Desmond

I am so keen on drawing patients that I spend my whole time on it. This is really how it is that I write so seldom. I believe my drawing is getting more definite; it begins to mean something. Though it is still exasperating.

I do anything for these men. I do not know why but I cannot refuse them anything & they love me to make drawings of photos of their wives & children or a brother who has been killed. A diary of a man who was killed chronicled the weather day after day & as you read these monosyllables it gives you an intensely dramatic feeling.

It is a most wonderful thing speaking to men; a great privilage. I could not help thinking of St Francis reply to the robbers that met him in the wood, when I was speaking to an Irishman. I had not said a word & he was arguing with someone & he turned to me & asked me what I thought about the 'after life'. I said that as the very being of joy exists in that it is eternal, it is only reasonable to suppose that life which only lives by joy must necessarily be eternal.

If these men have not gripped the essential, there is one grand thing: they are part of the essential.

I wish you could see the sea here. On a sunshiny day the deep blue sea, all ribbed, like in a Claude Lorraine & the gleaming froth along each 'rib' & the shadows of the ships on the surface of the sea. I am sure you would say it was "blithe and debonnaire". And the hills beyond all, bronze with the sunlight on them.

A man told me last night that an old man in France used to bring his trap & pony round & sell sweets to the men & one day he had gone into a pub & this man, who is a most magnificent man to look at, noticed his cart & knew also that by reason of the old man having left his cart for a drink that the oldyin had 'sold out' – & trotted it off to a place where was a five barred gate, on arriving at this gate he unharnessed the pony: shoved the shafts of the trap through the gate & harnessed the pony in to the shafts on the other side of the gate. So there it was the pony & trap harnessed together; the trap on one side of the gate & the pony on the other & the gate shut. This patient described the way the old man went to the ponys head & carefully pulled it a little bit forward & then backed it a little, fearing he

might pull the gate down if he went desperately at it. I think the story is so French. On another such occasion the spirit moved him & he simply smarmed the cart & horse all over with green paint & the poor old boy simply cried when he saw it. The brute. But at the same time it was only because he had the paint with him & a big brush & the temptation must have been very pressing.

[Side of letter on page 1] I am glad you describe your visits to your friends in Bristol that I know. It is great to get glim of Miss Krauss's studio. I shall come to Bristol again after the war.

Your affectionate friend Stanley.

Letter 20

An extended reminiscence of Cookham
Seven sides of text
Written from Salonika, possibly March 1917

I am walking across Cookham Moor in an easterly direction towards Cookham Village, it is about half past 3 on a Tuesday afternoon and I have just seen mama to the station. Walking up on to the causeway between the white posts placed at the eastern end, is Dorothy Bailey; how much Dorothy you belong to the Marsh meadows, and the old village. I love your curiosity & simplicity, domestic Dorothy. I can now hear the anvil going in Mr. Lanes Blacksmith shop, situated on the right of the street, & at the top end of it, as I walk towards it. The shop is over shadowed by a clump of pollarded elms which stand just outside the old red bricked wall which is built round Mr. Wallers house. Appearing above the elms & part way between them & a Ceda tree which rises from the garden enclosure formed by the wall, are Mr. Wallers malt houses with their slate roofs & heavenly white wooden cowls: the work of the cooper; I love to think of that. Every thing is so dull, the sun shines, the sky is blue, out there is an occasional young girl with some wreath which she is taking to her mothers grave. She has a pair of new shoes on, all shiny black. So unhappening, uncircumstantial & ordinary. The girl is going to the new Cookham Cemetery built halfway along the lonely road leading from Cookham to Maidenhead. Mama is safely packed off to Maidenhead & now I can let the bath-chair swerve all over the causeway

Stanley (third from left) and Gilbert (back row, right) with the Bailey girls
photographed by William. Dorothy Bailey is in the middle of the back row

The Blacksmith's shop, Cookham
Both photographs courtesy, Stanley Spencer Gallery, Cookham

Playing marbles on Cookham High Street.
Courtesy, Stanley Spencer Gallery, Cookham.
[By kind permission of Jill Clark, photograph by William Bailey]

and go where it likes while I enjoy the eternal happiness of this life irresponsible. And now as I enter the village I hear the homely sound of the Doxology, which the children of the 'back lane' school are singing. The 'back-lane' cuts at right angles across the top end of the village, and being semicircular in shape it appears again at the bottom of the village. The sound of the children's voices as they come teeming along the lane; prisoners set free; comes across the top end of the street & hits the Thames side of the street causing echo upon echo which getting in between the maltings becomes scary and hollow. I am now walking down the street. Mr. Tuck's milk cart is standing outside his shop having just returned from one of its rounds. The ice is being taken under the arch by the side of Mr. Caughts butchers shop, it is being dragged along the ground by a big king of pair of callipers. He has an awful yet fascinating way of clutching this ice. I enter our house, close the front door and look down the passage. At the further end the door leading into the kitchen stands wide open and the kitchen is flooded with sunlight. The plates and dishes on the tall dresser, in serried ranks along the shelves arranged, one plate overlapping the other glisten sparkling bright in the sunlight. The shadow of the maid shifts about over

Cookham: the Crown Hotel, left, with Keeley's cottages, right.
Courtesy, Stanley Spencer Gallery, Cookham.
[By kind permission of the family of Kate Swan (née Francis)]

different parts of the crockery as she buises about getting tea. I go into the dining room, the cloth is laid & I sit down to the piano & look at my Bach Book. Tea at length comes in and I sit down and take 3 pieces of bread and butter and a big cup of tea. Then I have some more. Then I get up and look out of the dining room window down our garden to the bottom of it where rises a big Walnut tree which spreads out over our garden and over the gardens on either side of us and over a big orchard at the bottom of the garden but I am more particularly looking at the yew tree which is framed by the Walnut tree forming the background. This fir tree has many apatures, openings etc which greatly excites my imagination. They all seem holy and secret. I remember how happy I felt when one afternoon I went up to Mrs. Shergolds and drew her little girl. After I had finished I went into the kitchen which was just such another as our own (only their kitchen table and chairs are thicker and whiter) with Mrs. Shergold and Cecily. I nearly ran home after that visit, I felt I could paint a picture and that feeling quickened my steps. This visit made me happy because it induced me to produce something which would make me walk with God. "And Enoch walked with God and was not." To return to the dining room I remain

Holy Trinity, Cookham. Courtesy, Stanley Spencer Gallery, Cookham

looking out of the big window at the Yew tree and the Walnut tree which nearly fill the space of the window, and then turning to Sydney ask him to play or rather try to play some of the Preludes. He does so, and though haltingly, yet with true understanding. And now for 2 or 3 hours of meditation. I go upstairs to my room and sit down to the table by the window and think about the resurrection then I get my big bible out, and read the Book of Tobit; while the gentle evening breeze coming through the open window slightly lifts heavy the pages.

I will go for a walk through Cookham Church yard I will walk along the path which runs under the hedge I do so and pause to look at a tombstone which rises out of the midst of a small privet hedge which grows over the grave and is railed round with iron railings. A little to the right is simple mound, guarded at either end by two small firs both are upright and elliptical in shape. I return to our house and put it down on paper. I think still more hopefully about the resurrection. I go to supper not over satisfied with the evenings thought, but know that tomorrow will see the light, tomorrow "in

Spencer at
Holy Trinity,
Cookham,
late 1950s.
Courtesy,
Stanley
Spencer
Gallery,
Cookham

my flesh shall I see God". And so I go to sup: Mama is home from
Maidenhead where her business has been chiefly in making bargins
at 6 ½d. Bazarrs and in nearly getting run over. There are cherries
for supper cherries and custard. It is dusk and the cherries are black
I have a good gossip with Mama or any one good enough to give
me some gossip. Then I go out and walk up to Annie Slacks shop
and sit in the shop and watch the customers. After the great doings
of night are over and the shops closed I just have one deliberate
walk round by the "Crown Hotel" down the Berries road along the
footpath to the river-side then along by the river through Bellrope
meadow to the Lethbridges garden end of the meadow and then I
stand still and the river moves on in a solid mass; not ripple. I return
the Berries Road way to the village and when I come to that part of
the road where you can look across to the backs of the houses
running down the north side of the street I stop again. Then I
return home and go straight up to bed having Crime and Punish-
ment under my arm and a candle which would last a life time. I get
into bed and after reading for about 2 or 3 hours I blow out the
candle, and whisper a word to myself "Tomorrow" I say and fall

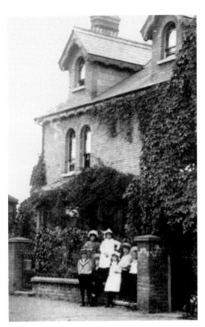

Fernlea, the Spencer family home in Cookham. Courtesy, Stanley Spencer Gallery, Cookham. [By kind permission of Jill Clark, photograph by William Bailey]

asleep. I do not ever remember the exact moment of waking up and more than I know the moment when sleep comes.

But although the moment of waking is not known; yet the moment when you become aware that it is morning; when you say "its morning" is the most wide awake moment of the day; I lay on the bed and look out of the open window across the road to Oveys Farm, then I turn my eyes to the room and let them rest on the wall paper which is covered with small roses. The reflection in the western sky of the sun rising in the east, casts a delicate rosy bloom on to this part of the wall. How everything seems fresh and to belong definitely to the morning. The chest of drawers now is not anything like the chest of drawers of last night.

The front of our house is still in shadow and casting shadows across the road but the Farm house opposite with its long red tiled roof is receiving the full blessing of the Dawn. The white doves are circleing round and round the farm yard: now over the barn, now casting shadows slanting up the side of the roof of the old farm house now rising up, and nearer and nearer, now they are over our house I can hear their wings going. A slight breeze comes in through the window. Annon they appear a little off to the left and

slanting downwards. Then they rise a little to the farm roof and then "banking" a little they alight on it and bask in the sun.

The sun has now just reached the street and the shadow of passing veichels sweeps slowly across the ceiling. I hear a rumbling cart coming. It is coming round by Mr. Llewellens house. I hear the stones scrunching under the wheels, it's the mail cart. I know when it reached the Bell Hotel because the scrunching of the stones suddenly ceases and you now only hear the plop plop of the horses hoofs, and a muffeled rumble of the wheels. I hear Mr. Johnsons little boy call "Harry, Harry!" down below in the street, and annon I hear his scuttering feet across the gravel as he runs past our house. Our back iron gate swings open and its the iveyed wall out of which it is built, with a bang: then quick steps up the passage, then the sound of the milk can opening and of the jug drawn off the window cill. After fully enjoying the thought of all the varied and wonderful thoughts I am going to have during the day I get up & go & look out of the window Mr. Francis the baker is returning from doughing he is white all over with flour. He has long hair white with flour, and a white meek face. I go and call Gil in the little bedroom. Out of the window which looks towards the west is Elizer Sandalls garden. Then Elizer walks down the ash path, she lowers the prop holding up the cloths line and begins hanging cloths on stretching her skinny arms to do so, the rooks are flying overhead; they are going over to Mr. Lamberts Rookeries. I go down stairs, and takeing a towel I strole into the street. I walk down to the bottom of the street and call a friend, we all go down to Odney Wier for a bathe and swim. My friend has an Airdale terrier, a fine dog with magnificent head neck and shoulders. He jumps leaps and bounds about in the dewy grass. I feel fresh awake and alive; that is the time for visitations. We swim and look at the bank over the rushes I swim right in the pathway of sunlight I go home to breakfast thinking as I go of the beautiful wholeness of the day. During the morning I am visited and walk about being in that visitation. How at this time everything seems more definite and to put on a new meaning and freshness you never before noticed. In the afternoon I set my work out and begin the picture. I leave off at dusk feeling delighted with the spiritual labour I have done.

Letter 21

SS to Desmond, written from Salonika on paper headed
'YMCA SALONICA FORCES'.
Two sides of text.
Dated Easter Sunday, April 8 1917

Dear Desmond,

I received your letter on Monday last. I have been shifting from one Amb: to another so that my address has been altering all the time. My present address will be a reliable one. Having just washed some clothes in the stream, I feel more able to write. It is very hot in the day time, which rather takes the guts out of one. I read the Psalm: 119th in our book. I had a beautiful little Bible & when I looked in my valise for it on returning from the base, it was gone. So now I have no Bible only a Testament. 'The Garden of the Soul' which you gave me I gave to a very earnest Catholic in exchange for a soldier's edition of the Ordinary of Mass. I gave it to this man because I felt that he had more right to it than I had. He lent me a book called "Catholic Belief" & though it was only just an uninspired 'explanation' of the Catholic Belief, it led me to understand a great deal. What you say about the Protestants is true. But I do not look upon the Protestant Belief as an existing thing at all, & therefore out of argument. I think that what my friend Jacques Raverat said about the protestant is true. That they are "mean, unforgiving, hate the poor to get drunk, & think soap is a virtue". I quote this because it is so deeply true. That is what the protestant has become, because he has as you say lost the personal idea of God, & only because of that. But the protestant will be forgiven because he is ignorant. For instance if he once realized the awful necessity of understanding that Christ said I am & not in me is the Way, he could not remain in his ignorant former 'belief'. I did miss my hot cross bun. I did not have one last year. You cannot imagine how home appeals to me now. When we were at home we used to sit round the dining room table & each one of us had a big hot-cross bun for breakfast. In my bedroom at home when I woke up I used to look out of the

[side of letter] Remember me to your mother. Any news of the

114

friends you have introduced me to would delight me. How is Miss Krauss, Miss Pierce, Miss Smith, the Misses Daniell, Mrs D. & Mrs. Press?

open window across to the farm house opposite. I simply had to sit up & look in front of me, & the long red roof of the farm (Oveys Farm) with the lovely white pidgeons basking in the early morning sun would be right in front of me. All at once, up rise the pidgeons off the roof & begin to circle round & round, they rise as they get to our villa & go over our roof part way & then sweep down again (I can hear their wings going) & appear in my view a little before they check their flight before alighting on the farm roof. I used to watch these pidgeons when I was about 6 years old when – if I was not well – I used to sleep between my Mother & Father, who then slept in my room. You can imagine what lovely feelings I must have had as those doves rose up over our roof. I would get up & lean out of the window & look across to a clump of trees a little to the right & behind the Farm roof, & through the trees I could just see the clock of Cookham Church (Partly Norman;) 7.30. I go down stairs & up the passage, open the front door & out into the street. I go for a bathe. The sun catches the water; a long sparkling shaft of light. I swim in the shaft of light. I saunter back home to breakfast across Odney Common (once thought to be called the Isle Of Odin) & as I walk I think of what joy is before me; a whole day. I was longing for the day the night before because "I am going to do 'that'", I would say, and when I do it, it seems veritably to make the day a 'whole' day. A day full of prayer, & so definite & clear, you can divide the prayer into parts. (My address No 10066, Pte S. Spencer, 143rd field Ambulance, Salonica Forces.) One part actually in the stone or on canvas, or in me when at tea time I look out of the dining room window at our Yew tree & the Walnut tree framing it.

Your loving friend, Stanley

[side of letter] I am longing for a book of some sort. It does not matter much about the size. I should like anything like biscuits or cake or chocolate or anything except ginger bread & seed cake. I don't like that.

Letter 22

SS to Desmond, from Salonica
Two sides of text
Dated May 25 1918

Dear Desmond

Thanks very much for your letter which did not arrive until about 4 days ago. I was glad to have it as I did not know how you were & I hardly knew if to write or not. My address is now No 41812, Pte S. Spencer, 7th Btn Royal Berks Regt British Salonica Forces, Greece. I transferred last October but I have not yet been in the line.

I had a letter about a fortnight ago from the Ministry of Information, saying that I had been suggested by Mr. Muirhead Bone to be imployed on 'artistic' work, in connection with the War, for record purposes, & that a proposal was being sent to the War Office to secure my services in this connection.

Since I have so many things all gaping for the canvas, as Mrs Raverat says "Spirits seeking about for a body of flesh" I am gladly accepting the offer, & I hope the scheme matures.

June 3. I will let this letter go as I think all my letters will have to be fragmentary. If I get this job, I shall be able to show God in the bare 'real' things, in a limber wagon in ravines, in fowling mule lines. I shall not forget what you said about God "Fetching & carrying" it was something like that out of St Augustine's Confessions. Please requote them. And that wonderful 'gradual' passage out of the book of Wisdom. Please give my best remembrances to your mother who I hope is in better health. Have you any news of our Bristol friends. I shall come to see you when I return, but this place has a great hold on my mind. Mountains & Mule lines is all my thought.

Your loving friend, Stanley

Letter 23

SS Desmond, from Salonica
Four sides of text
Dated Sept.16 1918 [It looks as if the date originally said 26, but was corrected to read 16]

Dear Desmond

I quite agree with you in thinking that everybody is becoming conscious of a desire for Truth, but I feel that the poorer classes (only poor as touching filthy lucre) are not being given a proper chance to 'live'. It is well to give them enough to keep a family 'going', but still they will be heavily hampered, & their progress seriously impeded, towards attaining a really high understanding of Truth, purely through the fault of unnecessary, petty material inconveniences.

There are 3 quite capable & deep thinking young men in this camp & one a great friend of mine – all of whom can neither read nor write. We know that to attain the kingdom of heaven it is not necessary to be able to read & write. But imagine him picking up the Testament!

I pray for the time when it will be accounted sin in anybody not to know the Diabelli Variations. There is no such a thing as 'individuality', 'personality', and 'originality'. Every man has the same Name. His Name is the Resurrection & the Life. I know from my own experience that to have the main employment of the days of my life on doing 'necessary' labour, which in the majority of jobs is brainless, has had a direct influence on my mind in keeping me from the knowledge of God. Whereas if a man were employed a small part of his day on a menial task such as I have spoken of, it might be an assistance to him in feeling his true relation with the Spirit, at the same time giving him ample time to work for the Spirit. I can conceive an ambition & spiritual desire to make boots, but I feel that as soon as I had partly realized that ambition I should be craving for something better & so on. This should be so in every man. There ought to be an equal distribution of Labour. If any man is ignorant or fool or a knave, you & I are largely responsible.

I do not think this may be what is wanted but it is just how I think. It is wicked to think that we might be able to keep a man from the Kingdom of Heaven.

I will write at a more convenient time when it is not so hot.

Your loving friend

Stanley

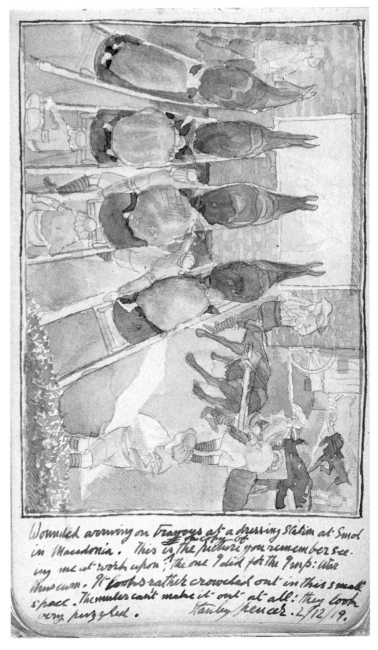

Watercolour copy of *Travoys* painted in December 1919 by Stanley
Spencer in the autograph album of Miss Gwyn Pinder-Brown,
daughter of a well-known Cookham family

A lot in this letter is clumsily written & a lot is not quite to the point, but where I am now I cannot concentrate & so this letter must go. Do write to me as often as you can, especially just now. Forgive me for not writing. Same address

Letter 24

SS to Desmond, from Salonica, Field Hospital
One side of text
Dated 'Oct. 5 1918 (?)' [it is unclear whether it is a 5 or 6]

Dear Desmond

I am in hospital for a few days with malaria though that has I think cleared off now. I have had a trying time recently & cannot write, my experiences seem to have quite unmanned me, so excuse me & write one of your beautiful long epistles like that last one to cheer me up & take my thoughts. The one & only book I have now is the little Crashaw book you sent me; it has been a continual comfort to me. Send me any little book you think I would like. I like Eric Gill & Douglas Pepler's ideas very much I would like to read a phamplet of theirs, or book. I can get to hear nothing of the job of War Artist that the Min: of Inf: proposed for me. I feel very weak. Do write, & forgive me for not writing. Send me a Bible with Apocraphe could you? If not with, then without. With love.

Stanley (Spencer)

Letter 25

SS to Desmond, from Salonica, Field Hospital
One side of text
Dated October–November 1918

Dear Desmond

I am still in hospital with Malaria, but I am a bit better, though I feel very weak. In some of the awful moments I have felt the need for greater faith, & afterwards I found myself asking the question: Christ has been adequate to me in all things, but is he in this? You must know something of what I mean, Desmond. It is an awful shock to find how little my Faith has stood in my stead to help me.

I have just read the life of King David as written in Samuel. I am slowly & with great joy reading the Psalms. I wish I had my great Big Bible which I have at home, containing the Apochropher & a lot of old steel engravings. It is about 3 times the length of this half sheet & about 3 times the width of it. Isn't a big Bible grand? Jacques Raverat (a great friend of Eric Gills) has an old edition of Miltons "Paradise Lost". It is great book & Jacques reads in a great voice.

> "In something combustion down to bottomless perdition, there to dwell in adamantine chains & penal fire."

I wish I could remember these Milton's lines better. Aren't his words wonderful, 'carrearing' wheels of the chariot.

I shall always be grateful to you for having sent me the little book of Crashaw. It has been my great stay & comfort. I can't feel that he is as sublime as Milton, yet he is more delicate & tender, & more sincere, that is he feels a thing more nearly, more personally. But Milton is so great in stature but perhaps only because he wrote an heroic epic.

[Side of letter] Send me any little thing to read. Do send me some of St Augustine.

With much love, your loving friend Stanley

Letter 26

SS to Desmond, from Fernlea, Cookham on Thames.
Two sides of text
Dated January 10 1919

Dear Desmond

Thank you so much for your letter. You can't imagine what I feel like: I thought I had gone beyond recall: too far removed, an awful feeling.

While I was out there, to think of the dear old Malt houses that there are in this village gave me almost a shock at times. And then suddenly & quite unexpectedly here I am & here is the malt house & I can pat it with my hand.

Did I tell you that in the train coming home there was a little girl seated next to me & she had such a dear little head, rather solemn

& meek, & her hair was long & massive & dark & one of the locks rested on my shoulder. Of course I only appeared to be interested in Lloyd George & Coalitionists.

And after such hardness you know, Desmond, harsh men & harsh sunsets & seeing no women for perhaps a year & then….yesterday I walked to a near town just to see people & as I was walking rather quickly up a side street a little kid a few paces in front of me fell with all her force (you know how children will fall with all their force; simply hurling themselves at the ground) off the pavement into the gutter. She picked herself up without a sound. I went up & asked her if she had hurt herself, but she was quietly weeping, not like most children, who, when they fall make a slight pause during which time they gather all the power they can contain, take a deep breath & burst into a terrific wail.

But this little one had not hurt herself much; the knee was a little bit grazed. But I was so overcome by this sudden demand on my sympathies that I quite forgot to tell her to go & get it bathed, but I led her, or rather she led me, to where she lived & so that was alright. I do not think I can come to see you yet much as I want to which is very annoying; I will let you know how this is in another letter.

I am having to work very hard. Have you heard from Lionel Budden at all? I have not. Remember me to your Mother. I hope she is well.

Your ever loving friend

Stanley S.

Gilbert, my brother, is still in Egypt.

Jan. 12. I have had a letter from Eric Gill and he wants me to come to Ditchling Common. Will you be there?

Letter 27

SS to Desmond, from Fernlea, Cookham on Thames
One side of text
Dated January 25 1919

Dear Desmond

I had a good time at Hawksyard, but I counted on seeing you. I feel

too tired to write now. Father John Baptist; you know him don't you?
My mother's coughing is very bad. How is your mother?

I do not write to you as often as I ought but I am always

Your loving friend Stanley

I will let you know how I get on & all about my picture.

Letter 28

SS to Desmond, written from
3 Vale Hotel Studios
Hampstead N.W. 3
Two sides of text
Dated July 20 1926

Dear Desmond

Please do keep the Back book until you leave Bristol as I do not at
present want it & you might like to use it while at home. I have just
bought a complete book of Robert Burns having during the last 6
months conceived a tremendous liking for him & I find reading him
a creative exercise. It's this domestic life business about him that is
so grand & makes one really look at things with all the freshness &
newness of seeing things for the first time. But what I want to ask
you for is where oh where can I find a book that contains those bal-
lads you wrote out in a letter to me at Bristol. One was

> [side of letter] Often other things dimly remembered by me
> is a quotation out of John of the Cross? It's about God real-
> izing man's love for variety & leading him by this variety to
> his one necessity, God. I have a number of your letters still
> but not the one which contained this.

called "The Pinnace" or "The Frigate", you could not quite remem-
ber. The other I Believe is more easily getatable, it's "Farewell to the
Spanish Ladies" – "Farewell Farewell ye Ladies of Spain ... From
Cape to Ushant is forty five Leagues." For the purpose of hoping to
find these, I have just bought the Oxford book of Ballads & of
course they are not in it. I still have the little tiny book of Scotch
ballads you gave me but it is not in this as I suppose it's not a scotch

one. I believe there were a whole lot of sea ballads (I don't mean shantys) you used to read to me. I don't know if I shall be able to come to Bristol, I only hope.

Yours ever

Stanley Spencer

Kind remembrances to you mother.

Letter 29

SS to Desmond, written from
3 Vale Hotel Studios
Hampstead N.W. 3
One side of text
No date on letter, but possibly 'August 1926'

Dear Desmond,

Gil is staying here & I have asked him about the Crucifixion & he thinks you had better take it & pay what you can. Gil recons £40 as the price but that if you can't manage that don't be afraid to say what you can manage, you have your whole lifetime to pay it in. If you stop dead at £35 or less, Gil may have mercy & let you off. If you can make a sufficiently good case of it you may be let off a good deal more. The point is Gil wants you to have it & the other point is that he wants money; can't resist it when its offered.

He may be coming to a place in Worcester & if he does he may like if you ask him to pay a visit to you. Though lord knows how this could be arranged.

Yours ever
Stanley S.

Gil's address is
The Plough Inn
Little Milton
Wallingford, Berks

Letter 30

SS to Desmond, written from
3 Vale Hotel Studios
Hampstead N.W. 3
One side of text
Postmark, 24 August 1926

Dear Desmond

I have to take Hilda & baby away for a holiday, which means I may be away when you are coming through London. So when you come you will have to get up to my flat somehow. It is very difficult to gain admittance when I am not here. If I lock my flat up (I don't usually) I will leave the picture of "Crucifixion" with Mrs. Knight the old girl who showed you where I lived. Her door is at right angles to mine. If I don't lock flat you will find the picture in my passage. Gil was delighted with your letter.

Yours ever,

Stanley S.

We may be away 3 weeks.

[Side of letter] My address will be: c/o Mrs. Lambert, The Hill, Wangford Nr Lowestoft, Suffolk.

Letter 31

SS to Desmond from
The Hill Wangford
Lowestoft
Suffolk
But listing 'Home address'
3 Vale Hotel Studios
Hampstead NW 3
Eight sides of text, dated November 17 1926

Dear Desmond

By the same post this morning came your letter & the New York Times containing the results of the Carnage Institute Pittsburg 'Pa'

International Exhibition. The contrast of the two things was glorious: American vulgarity & your request to me to continue Joachiming. How stupid all this 'International' talk is. I'll bet there is not a more monotonous show ever held any where than one would find at an 'International' show. It's all brought about through an unspiritual unimaginative & vulgar notion of <u>variety</u>. 'We have France with its uncompromising adherence to so & so, standing out sharply against Germany the land of etc. etc.' compared & contrasted ahha he-he what! What! Good God Almighty!

Not yet has it been realized to what extent & to what degree & in what way we have "erred & strayed" as it says in our C of E prayer book but this article in the American paper makes one feel all over the bloody shop. I never saw anything like it. One goes on reading "Only a painter as certain of his brush as Mr. Sims and as rich in scholarly experience etc." and one knows it's just bad & one has tea quietly & then suddenly it hits you in the face, bang.

Vulgarity is not such an easy thing to escape as one thinks, it's rather like a ghastly nightmare I once had of a thin strand of smoke that came creeping out of a grave & travelled in a thin line about 2 feet above the ground & everywhere it went it gave a terrible disease it was rank poisonus & a Mr. Godfrey a Cookham Gardener opened a hole in the wall of his house by taking a brick out of either end of a side wall of the house, thus creating a draught & the smoke attracted by the draught crept in & then the bricks were put in quick & closed up & there it was, & a few days afterward it began to percolate through the pores of the bricks. I think one catches sight of ones own vulgarity when one for a moment gets hold of something vital. I feel really that everything in me that is <u>not vision</u> is mainly vulgarity, different from American perhaps & not quite as vulgar but somehow <u>more</u> intolerable simply for that very reason. In the ordinary use of the word one sees some disgusting looking woman & one is simply repelled by the sight, but one cannot say why. In the same way when one has a great amount of spiritual vision anything in oneself that does not belong to that vision repels one <u>in exactly the same way</u> as does the woman.

It has always puzzled me the way people have always preferred my landscapes. I can sell them but not the Joachims. This fact of recent

years has had a <u>warring</u> effect on me, I began to wonder if my Joachim's were ambiguous but later in this letter I will explain certain 'Straying' & wanderings that I have done since the war. It was inspiring to be asked to do a Raising of Lazarous. I think the only way to paint a 'picture of the incident' would be to do as Christ did, <u>first</u> to rejoice & thank God, & then do the picture. That is real artistic vision when you are certain & sure about things & ideas before they have been given to you & before you have the least idea what they are like. That's the stuff to gie'em. In this private chapel war picture scheme I am doing, I asked my patron if I could do a Bible for the building & he seems keen on the idea. I would like just to do a Gospel. What a funny thing it is as soon as I contemplate the doings in the Gospel, I am fired at once, & yet I am not entirely in love with Christianity. I think it's this that one can love Christ without fearing that one is going to be brought up with a sudden jerk whereas with any other passion one fears a coul-de-sack. But several things during the years since the war have done a consider-able amount of havock to my 'faith' as an artist. You see, where you get real vision & artistic feeling You will notice that the vision appears not simply in one kind of product of an artist but in <u>every</u> kind. If brother Gil does a landscape it's got the same quality as his crucifixion & the same quality as a drawing of his of a head. This kind of spiritual uniformity seems to ratify the truth of Gil's vision to me. But with me, if I do a drawing of a head it's utterly worthless, it's nothing but a Slade drawing of a head. If I do a landscape it's dull & empty. If I do a composition of a resurrection or a visitation it's got something marvellous about it. This <u>unevenness</u> is very disturbing & in fact makes me feel dubious of myself altogether. I don't understand & feel very muddled. If what an artist does comes from the stem of Jesse it should be clearly apparent in <u>everything</u> that artist does. Being quite sure that this is so I naturally distrust as a result what <u>seems</u> to be good in the kind of work of mine that you specially like. I feel that such things may have a species of imag-ination in them but <u>not</u> artistic imagination. It's awful after 4 years at the Slade to find oneself not in possession of an imaginative capacity to draw but instead to find that one has contracted a <u>disease</u>. My capacity to draw & paint has got <u>nothing</u> to do with my vision,

since August - I should not have been in London if you had called so we were saved that disappointment. I quite agree (damn it -) that my John Donnes are prefer-able infinitly to my landscapes but - in these last landscapes: ~~the~~ especially one of a red house that you saw at Gonfils & one I have done (a big one) of a heap of string-ing nettles down here have both given me more insight into landscape painting & I really enjoyed doing them. This stingnettle one is more imaginative as a composition. I had real feelings about it & something is growing inside me as a result of having painted it; this last fact is what has made me feel that - my desire to be able to paint landscape is not without some reason. I have not yet been to the Gonfil show.

My stingnettles landscape is like this in shape The whole of the background is taken up by the back view of Wangford village.

it's just a meaningless stupid habit. This all sounds, horribly anyliticle but still it is what has put me off badly during the years since the war.

The John Donne picture is £5 to you, Sir. I have done 5 landscapes down here since August. I should not have been in London if you had called so we were saved that disappointment. I quite agree (damn it) that my John Donnes are preferable infinitely to my landscapes but in these last landscapes: especially one of a red house that you saw at Goupils & one I have done (a big one) of a heap of stinging nettles down here have both given me more insight into landscape painting & I really enjoyed doing them.

This stingnettle one is more imaginative as a composition. I had real feelings about it & something is growing inside me as a result of having painted it, this last fact is what has made me feel that my desire to be able to paint landscape is not without some reason. I have not yet been to the Goupil. My stingnettles landscape is like this in shape. [small ink drawing] The whole of the background is taken up by the back view of Wangford village.

This half a hemisphere of nettles attracts me & I feel as if I had discovered another planet. It is strange that I feel so 'lonely' when I draw from nature, but it is because no sort of spiritual activity comes into the business at all. It's this identity business. There are certain things where I can see & recognize clearly this spiritual identity in something but if I am drawing & don't see this clearly, it's all up. In fact the only impulse I have to draw or paint is that I know that somewhere in all these things there is this miraculous spiritual meaning that just in a flash in a second could change the boredom of drawing into a tremendous experience. I want to be able to see "John Donnes" & "Joachims" in the shapes of people's noses & mouths. One might say "oh well, why bother to draw heads & paint landscapes, why not just do John Donnes?" Well… think of the times I have looked at our baby girl & known that had I sufficient perception I could find untold treasures but instead I have to sit & gape at it & see nothing of all the the things that must be continually revealing themselves. The temptation in respect to the landscaping that I seem to go in for lies in the fact that both those landscapes you saw are now sold, one for £45 & the other for £55.

No, that isn't a temptation, it's just an irritating fact that people (to Hell with them) prefer my landscapes. Just think of it. It quite gave me a shock when I discovered it.

I am returning to Hampstead on Friday 19 November.

Yours ever

Stanley Spencer

Biographical notes on artists, teachers and patrons mentioned in the text

Spencer Family

The Spencer family consisted of father, William Spencer, known as Par; mother, née Anna Caroline Slack (Mar); William George (Will); Annie; Harold; Florence (also known as Flongy or Flo) who, when married became Florence Image; Percy; Julius; Horace; Sydney (also known as Hingy); Stanley (Tongly, sometimes Brer, and 'Cookham') Gilbert (also known as Gibbertry or Gil). Twins Gertrude and Ernest died in infancy.

John Louis and Mary Behrend

John Louis Behrend (1881-1972) and his wife Mary were principal patrons for Spencer and his contemporaries. They first met Stanley in 1914 at a party given by Lady Ottoline Morrell and purchased paintings such as *Swan Upping* soon after the First World War. Having been impressed by Stanley's plans for a sequence of wall paintings for a memorial chapel which they saw on a visit to Henry Lamb's house in Poole in 1924, they decided to build a small chapel to house the murals in the village of Burghclere, Hampshire, where the Behrends lived from 1918 until 1954. It was dedicated to the memory of Mary Behrend's brother, Henry Willoughby Sandham RASC who had died in 1919 from illnesses contracted on active service in Macedonia. Described by Henry Lamb's biographer as 'always kindly, thoughtful, sensitive, unobtrusive, and scrupulously fair' (Keith Clements, *Henry Lamb*, p.243), the Behrends also paid Stanley's rent at the Vale of Health Hotel, in Hampstead, when Stanley left Poole, and they built Ash Cottage in Burghclere to house the painter and his young family. J.L. Behrend's art collection – including work by Spencer, Sickert, Lamb, Edward Burra and Augustus John – was exhibited at the Leicester Galleries in May 1962. Lamb was commissioned in 1927 to paint a family portrait of the Behrends with their young son and daughter, which is now in the Brighton and Hove Museum of Art.

Muirhead Bone

Draughtsman, etcher and engraver, born in Glasgow, 1876. Studied at Glasgow School of Art having abandoned a career as an architect. He established a reputation as the 'London Piranesi', and became widely renowned for his mastery of architectural and industrial subjects. Britain's first official war artist, 1916-1918, and one of the few re-commissioned in the Second World War. A strong supporter of young British artists such as Spencer, Nevinson, Gwen John, Roberts and Bomberg, and a campaigner for many causes – Epstein's sculptures, free entry to public galleries, artist's copyright and Jewish refugee artists – as well as undertaking significant committee and Trustee work (Tate Gallery, National Gallery, Imperial War Museum). Knighted in 1937 for services to art and represented in most British collections, especially the British Museum with over 700 works, Sir Muirhead Bone died in 1953 in Oxford. Bone employed Stanley Spencer for a short while to teach drawing and painting to his son, Stephen. In 1921-22 Spencer stayed with the Bones in Steep, near Petersfield, Hampshire to prepare designs for a memorial hall in that village. Although that scheme failed to materialise through lack of patronage, it may have provided the stimulus for the memorial drawings that led to the chapel at Burghclere.

Professor Frederick Brown

Painter and teacher (1851-1941). In his late twenties, Brown transformed Westminster School of Art in the 1880s into the most progressive school of art in London. He became the Slade Professor of Fine Art at University College, and with his two assistants Wilson Steer and Henry Tonks taught some of its most notable students. As Professor between 1892-1917, Brown succeeded Alphonse Legros and taught many of the painters (and sculptors) who would dominate the late Victorian and Edwardian art scene: Augustus John, William Orpen, Mark Gertler, Gwen John, David Bomberg, Richard Nevinson and Stanley Spencer. Teaching primarily through demonstration and assiduous work in the life room and from the antique, both Brown and Tonks favoured observation, rigour and a painterly language derived from Ingres. In 1886 Brown co-founded the New English Art Club (NEAC) a group of British artists who had mostly trained in Paris and felt their work was

neglected by the Royal Academy. Early exhibitors at the NEAC included Steer, Sickert, and Whistler. Brown drew up the constitution, sat on all the committees and juries, and encouraged his Slade students to exhibit there.

Lionel Budden

A young lawyer from Dorset who struck up a lasting friendship with Stanley Spencer having discovered a mutual love of music. A talented violinist, Budden helped organise musical events and concerts in the Beaufort. With Chute, he and Stanley enjoyed their infrequent leave into the city, or walking around the grounds of the hospital. He, too, served in Salonika.

Hilda Carline

Born in 1889, Hilda was an established artist before she met Stanley in 1919, when she was 30 and he was 28. Her youth had been spent in a circle of Hampstead artists that included two of her brothers, Sydney and Richard. Stanley joined this circle after the war and accompanied the extended family on a painting trip to Bosnia. They married in 1925, in the parish church of Wangford in Suffolk where she had spent time as a wartime land-girl. They had two daughters, Shirin (b.1925) and Unity (b.1930). Motherhood put her painting on hold, but an exhibition in London in 1999 featured 72 pictures completed between 1910 and 1946 showing her to have been a painter of many qualities. Indeed, soon after meeting her, Stanley offered to buy one of her paintings of a group of sheep, writing in one of his long letters to her that he felt 'there is something heavenly in it' and 'the more I look at it, the more I love it'. After suffering from failing mental health, Hilda was diagnosed with cancer in 1947 and died in 1950.

Richard Carline

Painter, writer and administrator, Richard was born into a family of painters. During the war he, and his brother Sidney, became renowned for their paintings of aerial views of Mediterranean theatres of war. After the war his studio and family home in Hampstead became a popular centre for artists and writers, including Henry Lamb, John

Nash, and Stanley Spencer, whose work left a strong impression on him. Between 1924 and 1929 he taught at the Ruskin School, and had his first one-man show at the Goupil Gallery in 1930. An interest in African art developed in the 1930s and after the Second World War – when he supervised the camouflage of factories and airfields – he was appointed Art Counsellor to UNESCO. In 1978 he published a book on Stanley Spencer's Great War experiences and the chapel at Burghclere.

Dora Carrington
Carrington studied painting at the Slade School of Art between 1910-14, where she met C.R.W. Nevinson, Spencer and Mark Gertler. She gravitated towards the Bloomsbury Group, most notably Lytton Strachey with whom she set up home in 1917. She formed other relationships – living often in *ménages à trois* – with men and women, and produced fine portraits of Gerald Brenan, E.M. Forster, David Garnett, Strachey and others in the Bloomsbury set. She exhibited rarely, occasionally with the New English Art Club and produced woodcuts for the Hogarth Press. In 1932, aged just thirty-eight, following Strachey's death, she became depressed and took her own life.

Roger Fry
Painter, teacher and art critic, born in 1866. Taught art history at the Slade in the early 1900s, was appointed Curator of Paintings at the Metropolitan Museum of Art in New York where his interest in Cézanne supplanted his interest in the Old Masters. In 1910 Fry organised the exhibition *Manet and the Post-Impressionists* at the Grafton Galleries, London. Despite critical hostility he staged a 'Second Post-Impressionist Exhibition' in 1912, which featured many young British painters, including Stanley Spencer. One year later he founded the Omega Workshops, a design workshop based in Fitzroy Square, London, whose members included Vanessa Bell and Duncan Grant, whose abstracted colour forms took their impetus from recent developments in French art, namely the work of Matisse. In 1933, he was appointed the Slade Professor at Cambridge University. His most important publications were *Vision and Design* (1920), *Transformations* (1926), *Cézanne. A Study of His Development* (1927), and a study of Matisse published in 1930.

Henri Gaudier-Brzeska

Born as Henri Gaudier in St Jean de Braye, near Orleans, France in 1891. Without formal training he became a sculptor, moving to England in 1910 working in Bristol and then London where he met the Vorticists and became a founder member of the London Group. He was accompanied by Sophie Brzeska, a Polish writer whom he had met in Paris, appending her surname to his, to become known thereafter as Henri Gaudier-Brzeska. Abandoning the inspiration of Rodin he became influenced by the direct carving of Epstein. At the outbreak of war he enlisted with the French infantry, fighting with bravery and decorated for his actions. He died in the trenches at Neuville St Vaast in June 1915. Despite only four years as an active sculptor, Gaudier-Brzeska left a distinctive impression on twentieth-century sculpture in England and his work is still revered as the epitome of modernist energy and organic carving.

Mark Gertler

Son of Polish Jews, born in 1891, and brought up in poverty in Whitechapel, London. After attending art classes at the Regent Street Polytechnic and a short period as apprentice to a firm of glass painters, he won a national art competition and gained a place at the Slade School of Fine Art. A talented realist painter, Gertler's prospects were helped by the close patronage of Edward Marsh. His undisputed masterpiece is a singular indictment of the war: *Merry-go-round* (1916; London, Tate), which describes a nihilistic image of uniformed figures spinning ceaselessly on the war machine. With this work, Gertler turned his back on French influences which he dismissed as 'too refined for us – too sweet. We must have something more brutal today.' Gertler mixed with painters in Lady Ottoline Morrell's circle but was devastated by Dora Carrington's shift of affections from him to Lytton Strachey. In the 1920s his work became gentler and more subtle in colour, with a pronounced neo-classical style, but he failed to achieve the success he yearned for and spent increasing bouts in sanatoria as a result of recurrent tuberculosis. In 1939 he took his own life.

Eric Gill

Born in Brighton in 1882, Gill studied at Chichester Technical and Art School, and with architect W.D. Caroe, specialist in ecclesiastical architecture. He took evening classes in stone masonry at Westminster Technical Institute and in calligraphy at the Central School of Arts and Crafts. In 1903 he gave up architecture to become a calligrapher, letter-cutter and monumental mason. A year later, he and his family moved to Ditchling in Sussex, which he would later establish as an artists' community. There, Gill produced his first sculptures, including the commissions in 1914 for the *Stations of the Cross* at Westminster Cathedral, London. After the war, with Hilary Pepler, Desmond Chute and Joseph Cribb, Gill founded *The Guild of St Joseph and St Dominic* on Ditchling Common. Amongst his pupils was the young David Jones. Gill designed many memorable typefaces, amongst them *Perpetua*, its upper case based on monumental Roman inscriptions, and *Gill Sans* in 1927-30. Soon after he designed the typeface *Joanna* used in his *An Essay on Typography*. Amongst his other significant works are the sculptures, *Prospero* and *Ariel*, for the BBC's Broadcasting House in London (1932), stamps for the Post Office (1937) and *The Creation of Adam*, three bas-reliefs in stone for the League of Nations building in Geneva (1938). He designed the fascia board for Douglas Cleverdon's bookshop in Bristol. He was conferred a Royal Designer for Industry by the Royal Society of Arts and became a founder-member of the newly established Faculty of Royal Designers for Industry. He died in 1940.

Henry Lamb

Born in Australia in 1883, educated at Manchester Grammar School, Lamb first embarked on a career in medicine studying at Manchester and Guys, London, but abandoned the profession to become a painter studying at La Palette in Paris. A founder member of the Camden Town Group he saw active service in the Royal Army Medical Corps (in Macedonia and Palestine) and was awarded the Military Cross for conspicuous gallantry for removing wounded while under heavy shell-fire. He first met Stanley Spencer in 1913 and their friendship was sustained throughout the war. In the following decade Lamb provided support, shelter and friendship for the younger painter. Lamb is noted

for his striking portraits, particularly his full-length portrait of an elongated Lytton Strachey. He was elected an Associate of the Royal Academy in 1940 and a full Member in 1949, Trustee of the National Portrait Gallery from 1942 and of the Tate Gallery, 1944-51. In 1928 he married Lady Pansy Pakenham, daughter of the 5th Earl of Longford. Lamb died in October 1960.

Maxwell Gordon Lightfoot
Born in Liverpool in 1886, he began his art school training at Chester School of Art, moving to the Slade in 1910 where he painted atmospheric pastoral scenes and became known for his dramatic sepia illustrations of figures and trees. He exhibited his work in Liverpool and at the New English Art Club, attracting the attention of Spencer Gore who invited him to show with a small circle of artists at 13 Fitzroy Square and subsequently joined the Camden Town Group, although he resigned after their first exhibition in 1911. That same year, after a dispute with his parents about his engagement to an artist's model, Lightfoot cut his throat with a razor and died of his injuries. He was twenty-five years old. His death had a profound impact on those in his class at the Slade, including Stanley Spencer, who valued his friendship and recognized his extraordinary promise.

Edward Marsh (1872-1953)
A patron of artists and writers, he was Winston Churchill's private secretary during the First World War. He later became a trustee of the Tate Gallery and Chairman of the Contemporary Arts Society. In his will he bequeathed Stanley's *The Apple Gatherers* and *Self Portrait* of 1914 to the Tate Gallery, London.

Lady Ottoline Morrell
Born 1873, she was granted the rank of a daughter of a duke with the title of Lady when her half-brother William succeeded to the Dukedom of Portland in 1879. With her husband, Phillip Morrell she established herself in Bloomsbury (until 1915) and became renowned as a society hostess and an influential and generous patron of the arts. Their subsequent home at Garsington Manor, east of Oxford was open house to a

revolving crowd of artists, writers and musicians including Lytton Strachey, Henry Lamb, Aldous Huxley and Bertrand Russell. There are many photographs in the National Portrait Gallery of visitors to the Manor, including several of Gilbert Spencer taken in 1925-26. She died in 1938.

John Nash

Born 1893, worked first as a journalist but, encouraged by his brother Paul, took up painting. After long and tough experience in the trenches of the Western Front he returned to painting, primarily of landscape in oils, watercolours and wood engraving. His experiences with the Artists' Rifles in France and Belgium resulted in some of the most striking images of the war, including an attack at Marcoing in December 1917. He taught at the Ruskin School of Art in the 1920s, and for two long periods at the Royal College of Art. Until his death in 1977, he lived near Colchester, developing an expertise as a gardener and plantsman, becoming a fine painter and illustrator of the East Anglian countryside.

Paul Nash

Born 1889, after a difficult childhood Nash studied at the Slade School of Art, 1910-1911. He had a short spell of active service in the trenches with the Hampshires, but was invalided out of the front-line on the eve of a battle that caused the death of most of his fellow officers. After the war he quickly established a reputation as one of the most evocative landscape painters of his generation. In both wars he produced some of the most striking and memorable images of the war and home fronts. Nash was also a pioneer of modernism in Britain, promoting the avant-garde European styles of abstraction and Surrealism in the 1920s and 1930s. He co-founded, in 1933, *Unit One* with Barbara Hepworth, Henry Moore and critic Herbert Read. Nash was drawn to southern England Landscapes with a sense of ancient history – the stones at Stonehenge and Avebury, burial mounds, chalk downlands, and seasonal rhythms. Arguably, his paintings form the backbone of British landscape painting of the twentieth century. A chronic asthmatic, Nash died in 1946.

CRW Nevinson

Born 1889, son of war correspondent H. W. Nevinson. After St John's Wood School of Art, he was a contemporary of Stanley Spencer at the Slade School of Art, where he coined Stanley's nickname 'Cookham'. They were often at odds with each other, invariably ending in a brawl. Initially influenced by Impressionism and Post-Impressionism, his painting took a decisive turn after seeing the Futurist exhibition at the Sackville Gallery, London in 1912. Moving to Paris, where he met many of the leading avant-garde artists of the day, he became affiliated with Futurism and championed Marinetti's visits to London on the eve of the Great War. Nevinson's unmitigated support for Marinetti and the Italian Futurists alienated many of his fellow painters and he found himself at odds with his peer group, an isolated posture that he courted and nurtured to the delight of the press who tracked and reported his every move. Nevertheless, his work became hugely popular during the war when he proved singularly capable of fusing realistic observation with the harsh angular geometrics of the modern movement. Poor health, an abrasive and pugnacious temperament and the erratic quality of his paintings dogged his late war work, and he lost momentum after the Armistice, opting for a naturalism tinted by dynamic fascination with city life. He died in 1946.

Gwen and Jacques Raverat

Painter and wood engraver Jacques (1885-1925) studied at the Slade in 1910; his future wife Gwendolen Darwin (1885-1957) also a painter and engraver studied there two years earlier. Gwen became a regular correspondent with Stanley Spencer during and after the Great War.

William Roberts

Born 1895 and apprenticed in 1909 to become a poster designer, he won a London County Council scholarship to study at the Slade where he gained a scholarship. Fascinated by Post-Impressionism and the Cubists, Roberts briefly worked for Omega Workshops with Roger Fry, but left to exhibit in Wyndham Lewis's Rebel Art Centre. Influenced by Leger and fascinated by the fusion of angular machine-like structures with the bustling life of the city, Roberts embraced the Vorticist cause, later

claiming that he – not Lewis – had been one of its originators. Gruelling years on the front-line with the Royal Artillery dented his interested in mechanistic forms and his post-war work was less pointed, concentrating instead on a more rounded working-class figure in an array of urban settings; cinema, street, music-hall, dance floor, factory. He taught for forty years at the Central School and exhibited regularly in London; his monumental figure compositions became a regular feature at the Royal Academy summer shows. He died in 1980.

Henry Tonks
English painter and draughtsman, born in 1862, who turned from a successful surgical career to painting when, in 1893, he was invited to join the staff of the Slade School of Art in London. A champion of Ingres, draughtsmanship and drawing from the antique, Tonks succeeded Brown as professor in 1919 and taught there until 1930, influencing a great number of British artists, amongst them Wyndham Lewis, Augustus John, Paul Nash, Mark Gertler, and Stanley Spencer. An accomplished draughtsman, Tonks painted several large works, including the *Founder's Murals* (1922) for University College London, and a significant commission for the war museum collection, derived from a visit to the Western Front in the company of John Singer Sargent. Defending craftsmanship, observational drawing and the figure to the end, he was always dismissive of modernism. He died in 1937.

James 'Jas' Wood
A life-long friend of Stanley Spencer, Jas Wood (1889-1975) was a self-taught painter and writer, with a specialist interest in Persia.

Sources

Much of the material for this book has drawn on the private letters and papers of Stanley Spencer held in the Stanley Spencer Gallery, Cookham. In addition, the Tate Gallery Archive (TGA) has three significant holdings: the Tate Archive Microfilm (TAM) of letters between Stanley and Henry Lamb, Florence Image, James (Jas) Woods, Richard Carline; Boxes 825 and 8212, the Spencer-Carline papers and correspondence; 733 series, the Stanley Spencer Collection. Much of the material is now widely available in biographies of the painter and in compilations of the correspondence, for example in Adrian Glew (see bibliography) although permission to access the originals must be gained from the estate. Acronyms and file numbers of the material used in the present study are as follows.

Chute Correspondence held at:

The Stanley Spencer Gallery
High Street, Cookham, Berkshire
SL6 9SJ 01628 471885
www.stanleyspencer.org.uk

IWM:

Stanley Spencer files, Imperial War Museum, London,
Dept of Art, Tate Gallery Archive:
TGA 733.2. *et seq.*

Numbered writings, c.1932-37
TGA 733.4.1 Diary 1926
TGA 733.4.3 Diary 1928
TGA 8055.44 Notebook 1934 [manuscript version]
TGA 733.2.55 Numbered writings 1936
TGA 733.2.86 Numbered writings, 1941
TGA 733.2.140 Numbered writings, February 1943
733.3.35 Notebook [1936-42]
733.3.83 Notebook / diary [1915]-1918
733.2.30 Numbered writings, September 1938
733.2.43 Numbered writings, 1938
733.3.10 Notebook, February 1938-43
733.3.81 Notebook [c.1920]

733.3.86 Notebook 1945-47
756 *et seq* Letters to Florence Spencer (later Florence Image) and to Mr and Mrs Spencer
8116. *et seq* and 8216 *et seq.* Letters to Jacques and Gwen Raverat
825.14 Post-war letters to Florence, Peggy Andrews
825.22 Letters to Hilda Carline (later Hilda Spencer)
8221.2. Letters to Sir Michael Sadler
8417 *et seq.* Letters to Gilbert Spencer, Richard Carline, Jas Woods
882.*et seq* Letters to Mary Behrend
8917.2. *et seq.* Letters to Dudley Tooth
945. *et seq* Letters to Henry Lamb
945.50 *et seq* Letters to Henry and Margaret Slesser

TAM Tate Archive Microfilm

Bibliography

There is an extensive bibliography on Stanley Spencer, much of it is referred to in the chapter notes to this study. Only the major sources are listed here:

Alison, Jane, 'The apotheosis of love', in *Stanley Spencer: the apotheosis of love* (London: Barbican Gallery, 1991) pp.11-27

Behrend, George, *Stanley Spencer at Burghclere* (London: Macdonald, 1965)

Bell, Keith, *Stanley Spencer: a complete catalogue of the paintings* (London: Phaidon Press, 1992)

Carline, Richard 'New mural paintings by Stanley Spencer', *Studio*, 96 (November 1928) pp. 316-23

Carline, Richard, *Stanley Spencer at War* (London: Faber, 1978)

Clements, Keith, *Henry Lamb: the artist and his friends* (Bristol: Redcliffe Press, 1985)

Collis, Maurice, *Stanley Spencer* (London: Harvill Press, 1962)

Daniels, Andrew, 'Stanley Spencer The Making of a "Singular Man": A Study of the artist and his motivation', unpublished typescript, 2002

Glew, Adrian (ed.) *Stanley Spencer: letters and writings* (London: Tate Publishing, 2001)

Gormley, Antony, 'The sacred and the profane in the art of Stanley Spencer', *Stanley Spencer*, exhibition catalogue, Arts Council (1976) pp. 21-3

Gough, Paul, *Stanley Spencer: Journey to Burghclere* (Bristol: Sansom and Company, 2006)

Gough, Paul, *A Terrible Beauty: British Artists in the First World War* (Bristol: Sansom and Company, 2010)

Harvey, Jeremy, 'The Stanley Spencer – Daphne Spencer Correspondence', unpublished MPhil dissertation, University of the West of England, Bristol 2011

Hauser, Kitty, *Stanley Spencer*, (London: Tate Publishing, 2001)

Hyman, Timothy and Wright, Patrick, *Stanley Spencer*, (London: Tate Publishing, 2001)

Bibliography

Hyman, Timothy, 'The sacred self', in *Stanley Spencer the apotheosis of love* (London: Barbican Gallery, 1991) pp.29-33

Jones, David, *Inner Necessities: The Letters of David Jones to Desmond Chute*, ed. Thomas Dilworth (Toronto: Anson Cartwright Editions, 1984)

Leder, Carolyn, *Stanley Spencer: the Astor Collection* (London: Thomas Gibson, 1976)

MacCarthy, Fiona, *Stanley Spencer: an English vision* (New Haven and London: Yale University Press, 1997)

Newton, Eric, *Stanley Spencer* (Harmondsworth: Penguin, 1947)

Pople, Kenneth, *Stanley Spencer: a biography* (London: Collins, 1991)

de Rachewiltz, Mary, *Discretions* (London: Faber, 1961)

Robinson, Duncan, *Visions from a Berkshire village* (Oxford and London: Phaidon Press, 1979)

Robinson, Duncan, *Stanley Spencer* (Oxford: Phaidon Press, 1990)

Rothenstein, Elizabeth, *Stanley Spencer* (Oxford and London: Phaidon Press, 1945)

Rothenstein, Elizabeth, *Stanley Spencer* (London: Purnell, 1967)

Rothenstein, John (ed.) *Stanley Spencer the man: correspondence and reminiscences* (London, Paul Elek, 1979)

Shewring, Walter, *Letters of Eric Gill* (New York: The Devin Adair Company, 1948)

Shewring, Walter, 'Desmond Chute, 1895-1962', *New Blackfriars* (January 1963) Volume 44, Issue 511, pp. 27-36

Stanley Spencer RA, catalogue of Royal Academy exhibition, 1980, with essays by Keith Bell, Andrew Causey and Richard Carline (Royal Academy of Arts, London, 1980)

Spencer, Gilbert, *Stanley Spencer by his brother Gilbert* (London: Gollancz, 1961; reprinted, Redcliffe Press, Bristol 1991)

Wilenski, R.H. *Stanley Spencer* (London: Ernest Benn, 1924)

Stanley Spencer: Journey to Burghclere

Paul Gough

204 pages with colour and black & white illustrations
Hardback £35
Softback £24.95
Sansom & Company Ltd

One of the unsung artistic glories of Europe

This is the first major study of the making of Stanley Spencer's great memorial based on his First World War experiences.

The author details and interprets Spencer's remarkable journey from cosseted family life in Cookham, through the menial drudgery of the Beaufort War Hospital in Bristol and the malarial battlefields of a forgotten front in Macedonia, to his unique visions of peace and resurrection in the Sandham Memorial Chapel at Burghclere.

Five years after the war, Spencer started making large drawings of a possible memorial scheme. The Behrend family became his patrons, funding a purpose-built chapel at Burghclere, a few miles south of Newbury. For five years, he toiled to produce the painted chapel that is now regarded as his masterpiece.

Using his own letters, illustrations and paintings, the book locates Spencer's work alongside other soldier-artists of the time and shows how his war experience of 'innocence, fall and redemption' derived from his personal story as orderly, soldier and patient.

Available from:

Stanley Spencer Memorial Gallery, Cookham;
Sandham Memorial Chapel, Burghclere;
bookshops; or
UK post-paid direct from the publishers: Sansom & Company Ltd.
www.sansomandcompany.co.uk
email: sales@sansomandcompany.co.uk
tel: 0117 973 7207

Sansom & Company